IMAGES
*of America*

# LAFAYETTE

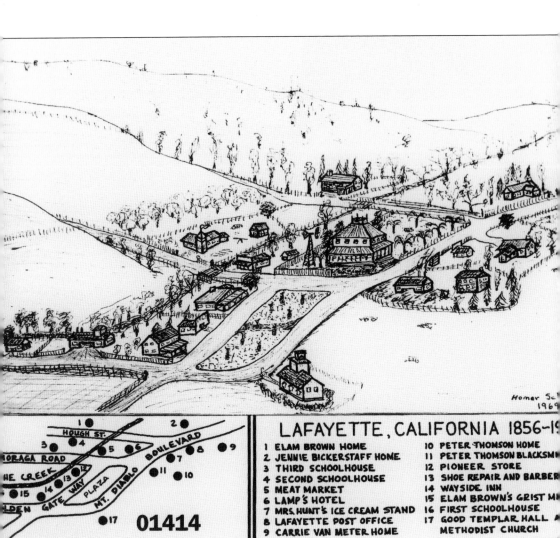

LAFAYETTE, CALIFORNIA 1856-19—

1 ELAM BROWN HOME
2 JENNIE BICKERSTAFF HOME
3 THIRD SCHOOLHOUSE
4 SECOND SCHOOLHOUSE
5 MEAT MARKET
6 LAMP'S HOTEL
7 MRS. HUNT'S ICE CREAM STAND
8 LAFAYETTE POST OFFICE
9 CARRIE VAN METER HOME
10 PETER THOMSON HOME
11 PETER THOMSON BLACKSM—
12 PIONEER STORE
13 SHOE REPAIR AND BARBER
14 WAYSIDE INN
15 ELAM BROWN'S GRIST M—
16 FIRST SCHOOLHOUSE
17 GOOD TEMPLAR HALL A—
   METHODIST CHURCH

A map drawn by Homer Schreiber in 1969 depicts early downtown Lafayette, including the location of homes and businesses on Mount Diablo Boulevard, Hough Street, Moraga Road, and Golden Gate Way. (Courtesy Christine Schreiber.)

ON THE COVER: The third Lafayette Grammar School was built in 1893 on Moraga Road on property that was purchased from Lawrence Brown in 1870. A special tax of $2,000 was levied to finance the building of the school. Margaret "Jennie" Bickerstaff graduated from the second Lafayette Grammar School in 1888 and was a teacher at the new school, earning $80 a month. Note the broken window above the front door of the school in this 1889 photograph.

IMAGES
*of America*

# LAFAYETTE

Mary McCosker and Mary Solon

ARCADIA
PUBLISHING

Published by Arcadia Publishing
Charleston, South Carolina

Printed in the United States of America

Library of Congress Catalog Card Number: 2007920167

For all general information contact Arcadia Publishing at:
Telephone 843-853-2070
Fax 843-853-0044
E-mail sales@arcadiapublishing.com
For customer service and orders:
Toll-Free 1-888-313-2665

Visit us on the Internet at www.arcadiapublishing.com

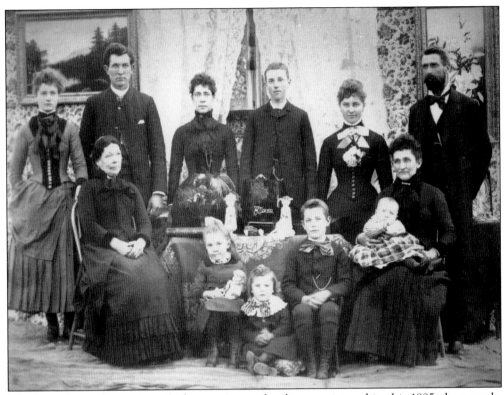

Members of several prominent Lafayette pioneer families are pictured in this 1885 photograph. From left to right are (first row) Mary Jane Hunsaker, May Elizabeth Daley Starks, Merle Leroy Daley, Oral Isaac Daley, Herbert Hiram Daley (baby), and Elizabeth Jane Hunsaker Daley; (second row) Grace Eleanor Daley Heron, Hiram "Doc" Hunsaker, Clara Hunsaker, James Edward Daley, Clara Minnie Daley Thompson, and James Marion Daley. Represented in this photograph are a teacher, two doctors, and a future store owner. (Courtesy Eleanor Meyers.)

# CONTENTS

# ACKNOWLEDGMENTS

To Daryl and Dan for their encouragement and patience; to Bill Eames and Harry Eisenberg for their generous gift of space for use by the Lafayette Historical Society; to the board of the Lafayette Historical Society: Ruth Dyer, Keith Blakeney, Marechal Duncan, Nancy Flood, Ollie Hamlin, Paul Sheehan, Tom Titmus, Jop Van Overveen, Dorothy Walker, George Wasson, Gary Willcuts; and to the following for their assistance on this project: Vic Anderson, Wilma G. Cheatham, Connie Collier, Donna Colombo, Fern Powell Davis, Chris Eaton, Michael Fisher, Emily Haas, Clint Harnish, Drew Hampton, John Harper, Tom Jackson, Sara Jacobs, Steven Jones, Sandy Kimball, Teri Lusk, Chung-Hay Luk, Betty Maffei, Tim McCreery, Mike Mederski, Joan Merryman, Marianne Millette, Dorothy Mutnick, John Nutley, Nilda Rego, Lewis Rodebaugh, Alice McNeil Russi, Gladys Shalley, Chris Schreiber, Bill Somerton, Muir Sorrick, Ed Stokes, Louis L. Stein Jr., Julie Sullivan, Lee and Avice Taylor, Bill Wakeman, Sybil Brown Wilkinson, Andrew Young, Valerie Zito, the Contra Costa County Historical Society, the Moraga Historical Society, the Orinda Historical Society, and the Tice Valley Rossmoor Historical Society.

# INTRODUCTION

For centuries, the Saclan Indians, a tribelet of the Miwok, inhabited the land that is now Lafayette. This group of indigenous people lived simply on the land, gathering acorns and hunting for their food. The area abounded with freshwater creeks and streams and many varieties of plants and animals, which were used for housing, clothing, and medicine, as well as food. These people were peaceful and lived in harmony with the land. With the arrival of the Spanish explorers in California, the lives of these people changed drastically. By the early 18th century, most of the Saclan were gone from the area, having died from the diseases brought by the Spanish, having become missionized by the Catholic Church, or having left the area to escape the rule of the white man. The land lay uninhabited for many years until the lure of inexpensive, fertile land brought Yankee settlers from the East.

Elam Brown was an Easterner by birth, having spent the early years of his adult life as a farmer in New York, Massachusetts, Ohio, Missouri, and Illinois. He married and had four children, but his wife died when he was 49, and at that time, he decided to make the trek across the plains to start his life anew in the West. Leaving from St. Joseph, Missouri, on May 1, 1846, Brown, as cocaptain of his wagon train, led 14 other families on a six-month journey in covered wagons filled with their most important possessions. Initially the group was headed to Oregon, but they heard stories that pasture conditions were poor on the way to Oregon, so they went south, taking the Emigrant Trail to California. Progress was slow as most of the people on the journey walked alongside the wagons that were pulled by plodding oxen. Sickness and death from "plains fever" (probably typhoid fever) struck the party. Margaret Allen's husband Isaac was one of those who died, leaving her to finish the journey alone with her children. The wagon train narrowly escaped an early storm in the Sierra Nevada that killed many in the Donner Party, and arrived in the Sacramento area in the fall of 1846. Elam Brown and Margaret Allen were married the following year and together purchased a land grant, Rancho Acalanes, from a San Francisco financier, William Leidesdorff, for $900.

In February 1848, Brown and his family settled in the Happy Valley area of today's Lafayette, becoming its first citizens. Brown initially sold parcels of land to several members of the wagon train and then to others who wished to settle in the area. As businesses, homes, a church, and a school were built, the community became established. Over the years, Lafayette, which was settled as a farming community, became more populated and more connected with surrounding communities.

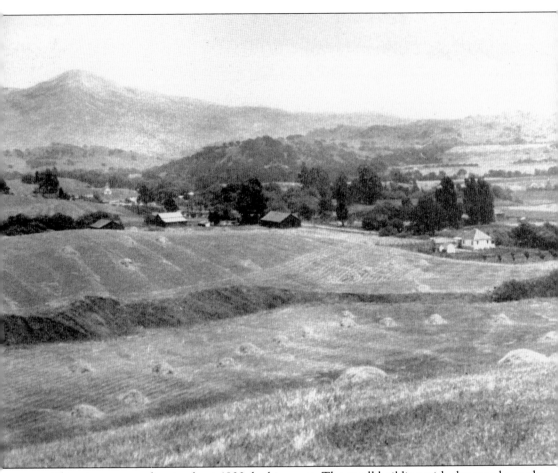

This picture was taken in about 1900, looking east. The small building with the steeple on the hill (upper left) is the Good Templar Hall. To the right is the hotel on the corner of what is now Moraga Road and Mount Diablo Boulevard. The large white house belonged to Frank Thomson. Adjoining that was farmland owned by Peter Thomson. By the tall trees was the James Bickerstaff house. (Courtesy Robert and Barbara McNeil.)

# One

# BEGINNINGS

The Saclan, a Miwok tribelet, lived in the area of present-day Walnut Creek and Lafayette. With the arrival of the Spanish explorers in the mid-1700s, the Saclan people began to leave the area due to death from foreign disease, flight from the Spanish missionaries, or missionization in San Francisco or San Jose. By the 1830s, the Saclan people had disappeared from the region.

Explorers from Spain first visited this area in 1772. Later, after the Mexican army defeated the Spanish and removed them from California, the Mexican government rewarded its soldiers for exemplary service, often gifting them land. Candelario Valencia, a sergeant in the Mexican army, was allowed to petition for land west of Mount Diablo, which was granted to him in 1834. He named this land Rancho Acalanes after the Saclan Indian tribe that had lived in the area. He ran cattle on the land but never planted crops on it. He sold it to William Leidesdorff, a land speculator from San Francisco, in the mid-1840s, perhaps to pay off a debt.

Elam Brown, a farmer who had lived in the eastern United States, decided to seek fertile land in California after his wife died in 1845. In May 1846, a wagon train of 14 families and 16 wagons led by Elam Brown left St. Joseph, Missouri, heading west. The journey took about six months, and several members of the group died of illness along the way, including Isaac Allen, one of the wagon train's cocaptains, leaving his wife, Margaret, a widow. The wagon train reached Sutter's Fort in California, and many of the train's members left to settle in other parts of the state. Elam spent the summer of 1847 in the San Antonio/Canyon redwoods of Contra Costa County whipsawing lumber. Finding that the Rancho Acalanes was for sale by Leidesdorff, Margaret and Elam, newly married, purchased the rancho for $900 (including 300 head of cattle). A portion of the money used for the purchase was carried to California, hidden in an eight-day clock belonging to Margaret. The Browns were among the first American settlers to farm in Contra Costa County.

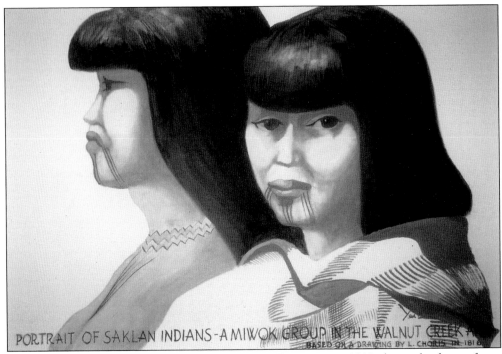

PORTRAIT OF SAKLAN INDIANS - A MIWOK GROUP IN THE WALNUT CREEK
BASED ON A DRAWING BY L. CHORIS IN 1816

This sketch by Louis Choris, drawn while in San Francisco in 1816, shows the faces of two Saclan Indians, a tribelet of the Miwok. Saclan people had short bodies, broad shoulders, and long, coarse hair. They painted their faces during celebrations, and women often tattooed their faces with lines to indicate the number of children they had. (Courtesy Contra Costa County Office of Education.)

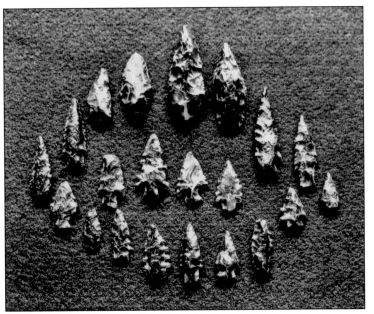

These arrowheads were found in the creeks near Lafayette Circle by longtime Lafayette resident Bill Wakeman when he was a young boy. Thought to be from 1,000 A.D., they were used for hunting by the Saclan peoples, who traded with neighboring tribelets for the obsidian. Bone, stone, and wood were also used in arrow making. (Courtesy Bill Wakeman.)

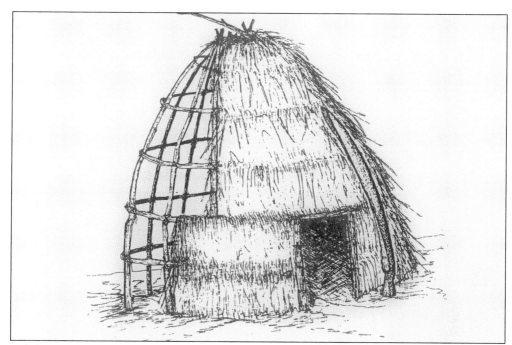

Tule houses were simply constructed from willow branches stuck in the ground, lashed together with willow bark at the top, and covered in tule grasses and leaves. The size of the hut depended on the number in the family. Saclan villages consisted of family units of 65 to 75 people, all that an area could easily support in food and clothing. (Courtesy Contra Costa County Office of Education.)

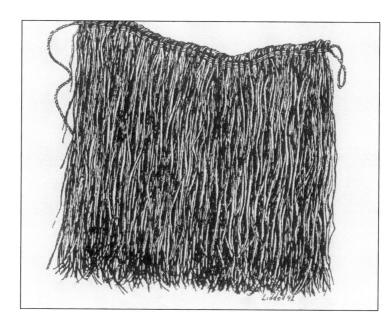

Willow bark skirts were worn by Saclan women during the warmer months of the year. Men and children usually wore no clothing at all, but in the winter months, both men and women often coated their bodies with mud to insulate themselves from the cold. (Courtesy Contra Costa County Office of Education.)

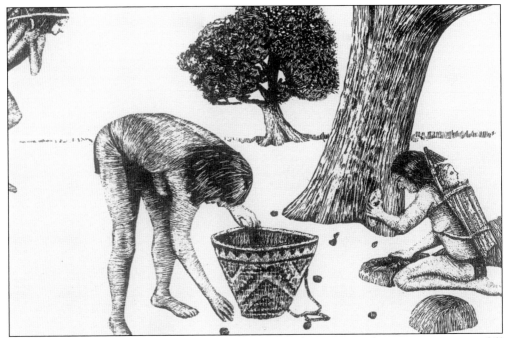

Acorns were used as a staple food for the Saclan, and many months were spent every fall gathering and storing these nuts for the winter ahead. A large oak tree could yield 300 pounds of acorns a year. Acorns were served as soup, mush, in biscuits and bread, and were gathered and stored in granaries and woven baskets until winter. (Courtesy East Contra Costa County Historical Society.)

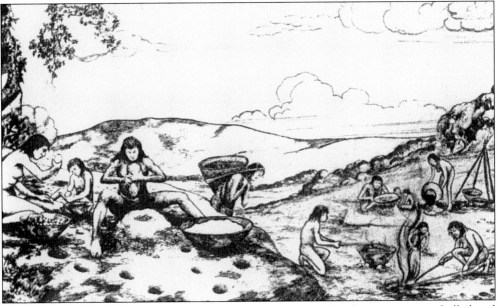

To eat the acorns, it was necessary to leach out the tannic acid. The acorns were shelled and the meat pounded in the mortar bowls worn in the bedrock. The pounded acorns were put in baskets and then rinsed as many as 20 times with hot water, a process that might take several days. (Courtesy East Contra Costa County Historical Society.)

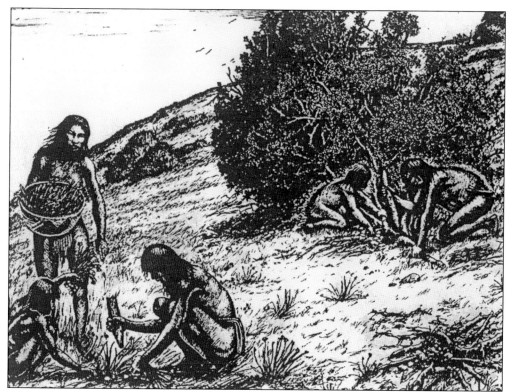

Most of the Saclan life was spent out of doors. Within each village was a central place where meals were prepared and men sharpened weapons and planned the hunt. The Saclan were not farmers. All food was foraged or killed. Nuts, grasses, and other plants were gathered or dug from the ground to eat. They drank water from the streams. (Courtesy Wilma G. Cheatham.)

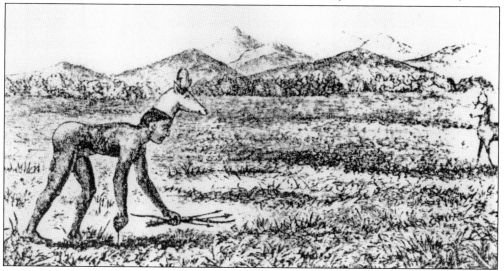

Saclan men hunted deer and other indigenous animals, often disguising themselves for the hunt. To mask their human scent, they rubbed their bodies with bay laurel leaves. Insects, especially grubs and larvae, were collected as well as snails and grasshoppers, which were roasted on hot rocks before being eaten. (Courtesy Wilma G. Cheatham.)

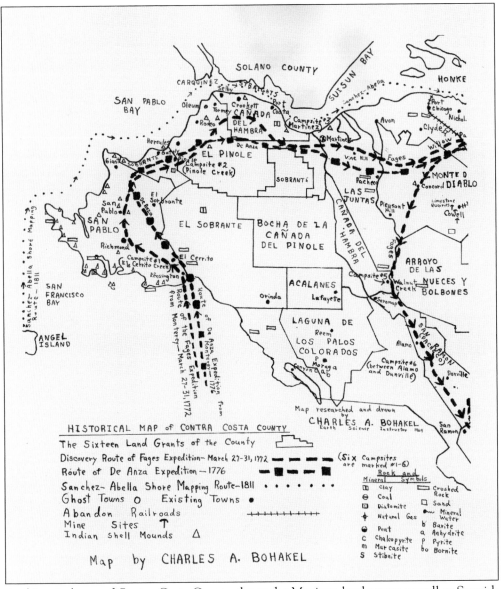

An historical map of Contra Costa County shows the Mexican land grants as well as Spanish expedition routes and other historical sites. Don Jose de Galvez ordered the establishment of missions and presidios east of the San Francisco Bay. Don Pedro Fages explored land east of San Francisco as far as Mount Diablo in March 1772. Don Juan Bautista de Anza, Jose Joaquin Moraga, and Fray Pedro Font followed Fages's route but returned on the east side of Diablo in March 1776. Moraga built the presidio and mission in San Francisco in June 1776. In the years that followed, Mexico and Spain warred for control of the California lands. In 1821, Mexico defeated the Spanish, and California came under the control of Mexico. (Courtesy Charles A. Bohakel.)

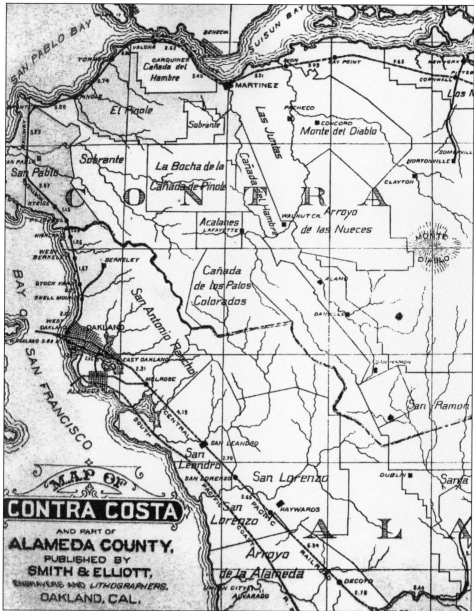

Rancho Acalanes, seen in this 1878 map, was the smallest of the Mexican land grants of Contra Costa and Alameda Counties. One of the most significant events of the Mexican period occurred in 1833, when the Mexican government secularized the missions, taking over vast mission landholdings and awarding them as land grants to those who had served the government, often in the army. Between 1821 and 1846, settlers from the East Coast began to settle in California. Many of these settlers, particularly those who had come by ship, married Mexican women (usually of the local aristocracy), became Mexican citizens, and obtained land grants. In contrast, the pioneers who came overland often brought families, stayed to themselves, and resisted integration into Mexican society. It was this group that rebelled in 1846 against the Mexicans and formed the Bear Flag Republic, which disappeared during the U.S. conquest of California. (Courtesy Contra Costa County Historical Society.)

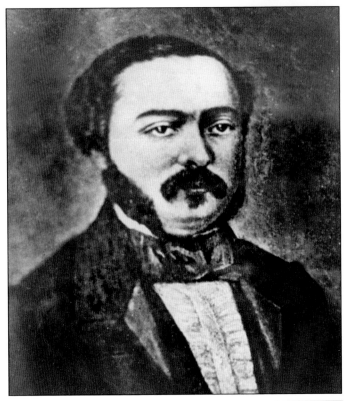

William Leidesdorff (1810–1848) came to San Francisco in 1841 and saw the potential of San Francisco as a seaport and trade center. He operated a trade ship to Hawaii, opened a general store, became a shipbuilder, and established a lumberyard. He invested in property that became the center of San Francisco's financial district and built the city's first hotel. He became a Mexican citizen to acquire real estate and was granted 35,000 acres east of Sutter's New Helvetia ranch near Sacramento. Shortly before his death in 1848, Leidesdorff purchased Rancho Acalanes, which he soon sold to Elam Brown. An 1893 map of Rancho Acalanes includes the names of many of the pioneer settlers, including Peter Thomson, Napoleon and Margeline Smith, James Gerow, C. Y. Brown, James Bickerstaff, and Hiram Stanage. (Above courtesy *Contra Costa Times*; below courtesy Lafayette Historical Society.)

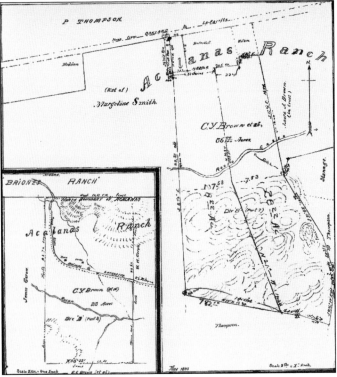

Margaret Allen (1794–1884) and her husband, Isaac, were members of Elam Brown's wagon train. Isaac died during the journey, probably of "plains" (typhoid) fever. Margaret herself became ill, and one of her young sons remembers he "had to drive the wagon, continually stopping and going to the rear of the wagon to brush the dust from his mother's face to see if she was still breathing." (Courtesy Alice McNeil Russi.)

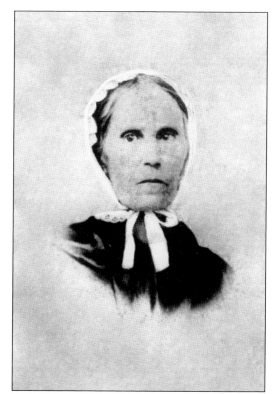

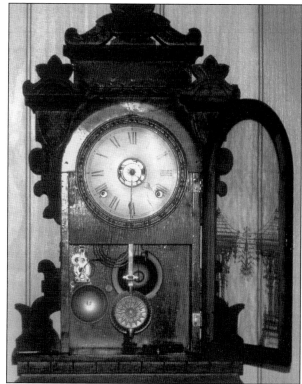

Margaret Allen carried this clock in her covered wagon on the six-month journey across the plains to California. It is said that she gave Elam a portion of the $900 to purchase Rancho Acalanes, the money having been hidden in a secret compartment in her eight-day clock, so named because it only needed to be wound every eight days. (Courtesy Donna Colombo.)

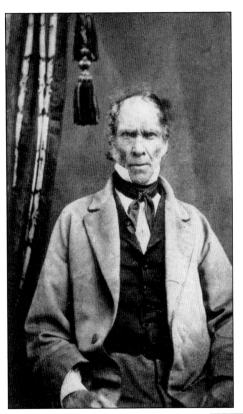

Elam Brown was the founder of Lafayette. In 1847, he purchased the 3,328-acre Rancho Acalanes for $900 from William Leidesdorff. He raised grain and cattle and built the first gristmill in Contra Costa County. In 1849, he was a delegate to the state convention at Monterey, which framed the state constitution. He served two terms as the county's first state legislator. (Courtesy Alice McNeil Russi.)

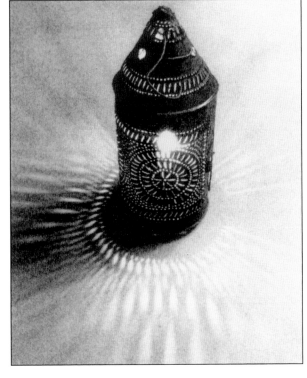

Elam Brown brought this lantern on the journey to California in 1846. It is made of hand-punched tin and was used during the wagon train's night stops to provide illumination in the darkness. Elam Brown gave it to James Bickerstaff, who later left it to his daughter, Margaret. It is thought to be one of the oldest known American artifacts in Contra Costa County. (Courtesy Lafayette Historical Society.)

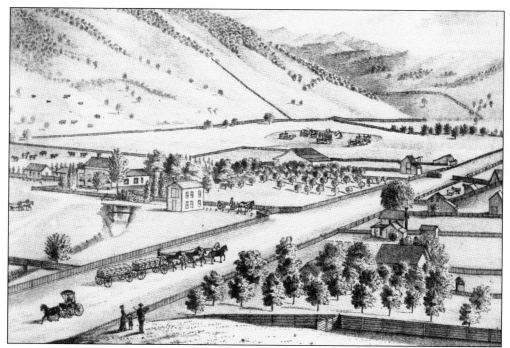

This is an artist's lithograph conception of Elam Brown's home and farm on Hough Street (today known as Lafayette Circle) c. 1849. An actual photograph would show it to be a more modest dwelling. Mount Diablo Boulevard, in the foreground, was in reality a narrow, winding road. (Courtesy Contra Costa County Historical Society.)

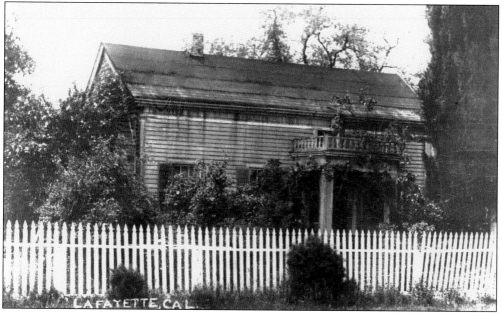

In 1849, Elam Brown built this home with wooden floors in downtown Lafayette so he could be closer to his gristmill business. He died in Lafayette on August 10, 1889, at the age of 92 and is buried in the old cemetery in Martinez. The house fell into disuse and was razed prior to 1930. (Courtesy Sybil Brown Wilkinson.)

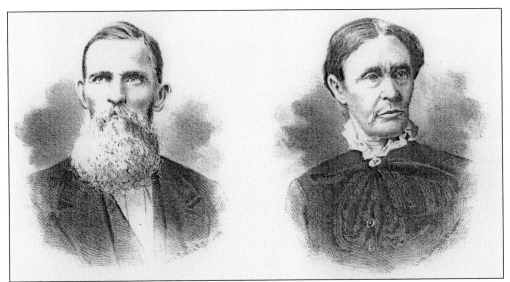

Nathaniel Jones and his wife, Elizabeth, daughter of Isaac and Margaret Allen, accompanied the Brown wagon train across the plains. After Elam Brown purchased the Rancho Acalanes, he sold Nathaniel Jones 372 acres in Happy Valley for $100. Jones called the property "Locust Farm" for the locust trees he planted from seeds given to him by Maj. Stephen Cooper of Benicia. Some of these trees are still standing in various locations in Lafayette. Jones served as the first sheriff of Contra Costa County, as well as a public administrator and a supervisor. (Both courtesy Contra Costa County Historical Society.)

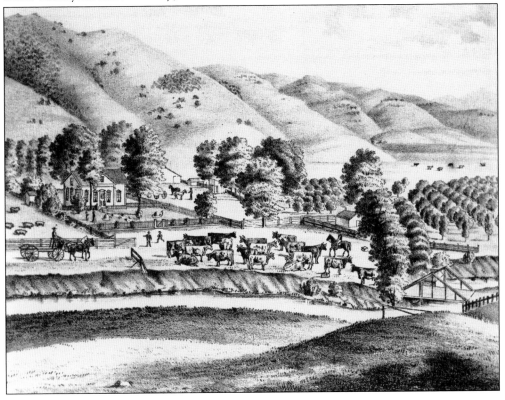

# Two

# TOWN CENTER

When Elam Brown first settled on the Rancho Acalanes in 1847, he chose only to run cattle, doubting he could grow crops in an area where there was little rainfall for half of the year; however, the following spring, he planted wheat in the valley. Within a few years, Contra Costa County was to become the greatest wheat-producing area in the state.

Three factors drew settlers to Contra Costa County: the fertile soil, which produced a high yield of grain; the need for food in San Francisco; and the need for supplies for the workers in the coal mines in eastern Contra Costa and lumber mills in the western part of the county, which could be supplied by early farmers. The route between the lumber mills and the port at Martinez crossed Rancho Acalanes, and Brown saw potential for a community to serve the lumbermen. But early wheat played an important part in the development of Contra Costa County as it provided the need and the money for the development of roads and communities.

Nathaniel Jones, who had accompanied Brown's wagon train and married Margaret Allen's daughter Elizabeth, came to the area to farm. Other early settlers included the Thomson, Bradley, Hough, Lamp, and Allen families. By the early 1860s, the town included Brown's gristmill, a store, a school, a blacksmith shop, and a hotel, all of which were located around the plaza, a 100-foot by 150-foot triangular piece of land the Browns had deeded to the town in 1864.

Three hotels were built in the vicinity of the Plaza Park beginning with Milo Hough's Hotel in 1853. Hough operated the hotel for several years before selling it to Benjamin Shreve. Later hotels were built at the intersection of Mount Diablo Boulevard and Moraga Road. A hotel at this location owned by Norman Hastings burned down in 1892. A third hotel built by Phillip Lamp suffered the same fate in 1925. No further hotels were built on "hotel corner."

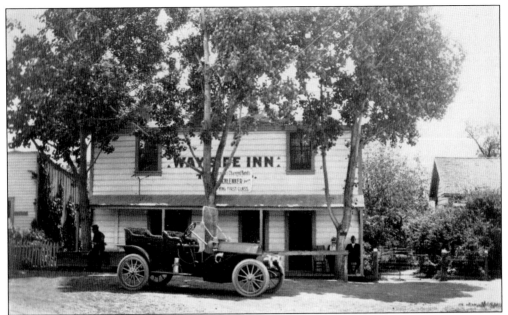

In the early days, the Wayside Inn was known as a "first class" hotel and tavern. Edward J. Brady built the two-story structure in 1894, when Lafayette was a stopping point for cattlemen driving their stock over the Berkeley-Oakland hills to the market. Dusty cowboys needed a place to quench their thirst and rest overnight before the hard ride over the hills. (Courtesy Alice McNeil Russi.)

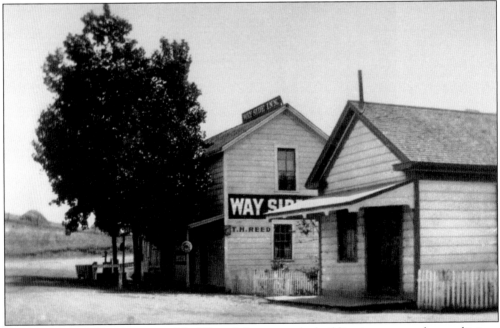

Thomas T. Reed, the proprietor of the Wayside Inn, gave the building its name and turned it into a saloon and rooming house. Some Lafayette insiders suspect that during its early days, "ladies of the evening" could be found on its second story. Catherine Geils, a dressmaker, owned the house to the right, which in later years housed the justice of the peace. (Courtesy Contra Costa County Historical Society.)

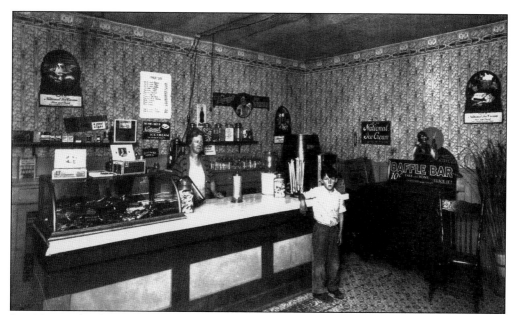

In 1921, Gerhardt "Pat" Medau bought the Wayside Inn for $2,850. Medau was a Spanish-American War veteran who married Lizzie Flood of Lafayette in 1901. He opened a meat market in the building. In 1925, he moved his meat market to Mount Diablo Boulevard and opened an ice cream parlor in the old inn. Lizzie Medau and her grandson Rothery McKeegan are seen in this photograph. (Courtesy Medau family.)

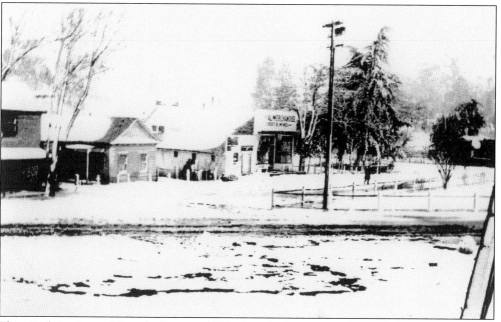

Plaza Park is pictured here in January 1922 after the big snow, an uncommon occurrence in Lafayette. On more balmy evenings, foot races and wrestling matches took place in the park. Boys played marbles while fathers talked over news from San Francisco's daily papers. Riders racing their horses around the park raised so much dust that William McNeil, owner of the Pioneer Store, fenced off the area. (Courtesy Alice McNeil Russi.)

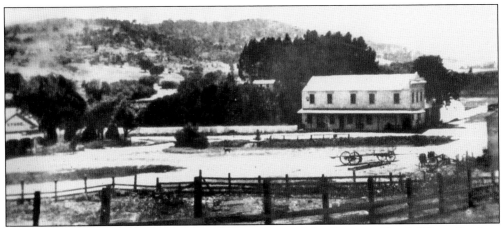

Norman Hastings, who had a son named Barney, owned the Hastings Hotel. When Hastings sold the hotel, Barney acted as if his family still owned it. One evening in 1892, Barney and some friends were refused service when the bartender determined that they were drunk. Barney returned later and started a fire, which burned down the hotel. He was sent to San Quentin State Prison. (Courtesy Lafayette Historical Society.)

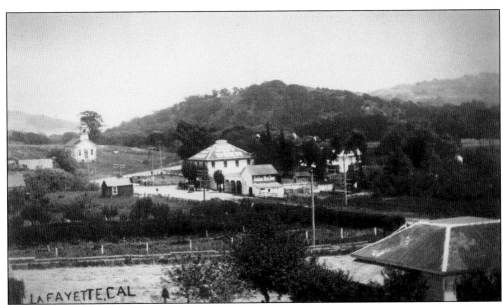

This photograph from the early 1900s shows the buildings on what is now Mount Diablo Boulevard. Pictured here are, from left to right, the Methodist church, the post office (the building with one window), Plaza Square (fenced), and Lamp's Hotel, on the corner of Mount Diablo Boulevard and Moraga Road. The sign on the roof of the hotel advertises Golden West Beer. (Courtesy Sybil Brown Wilkinson.)

24

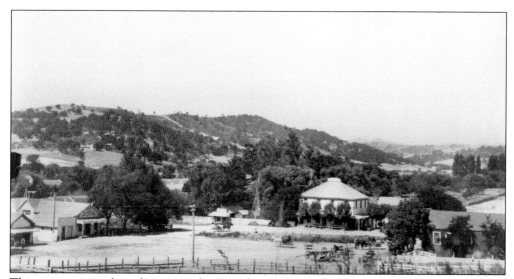

This picture was taken about 1910 showing, from left to right, the Geils Building, the Pioneer Store, Stark's Meat Market (the small building), Lamp's Hotel, and Peter Thomson's blacksmith shop. These were the earliest businesses built around Plaza Park on land donated to the community by Elam and Margaret Brown in 1864 "as a plaza for the benefit of the citizens of Lafayette." (Courtesy Alice McNeil Russi.)

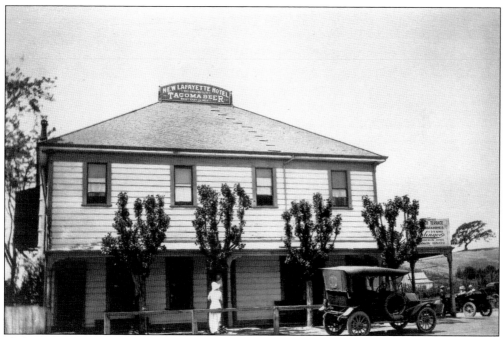

Philip Lamp built this hotel in 1900 at Mount Diablo Boulevard and Moraga Road. It served the community until 1925, when a cook left a pan of food on the wood range, starting a fire. The townspeople fought to save the business section around the plaza. The Walnut Creek Fire Department saved the town using water from Pat Medau's swimming hole, but the hotel was destroyed. (Courtesy Alice McNeil Russi.)

## Reception Committee.

JOHN SLITZ.        JAMES DALEY.

## Floor Managers.

E. FOLLET.        W. L. VINCENT.
L. C. WITTENMYER.

# Christmas Ball.

A Grand Christmas Ball will be
given at the

### LAFAYETTE HOTEL,

## LAFAYETTE,

On the night of the 25th of Dec. 1867.

*M. Madden, Proprietor.*

TOWNE & BACON, PRINTERS.

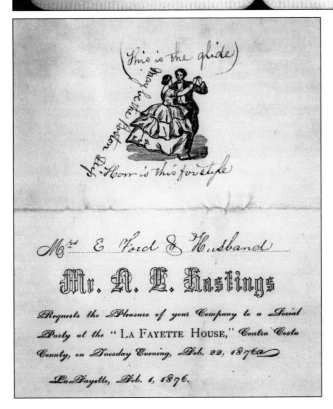

Pictured are programs for a Christmas Ball held at the Lafayette Hotel in 1867 and for a social party at the La Fayette House Hotel in 1876. Throughout its history, Lafayette was known for its parties and dances. Handwritten around the drawing of the dancing couple are the following inscriptions, "This is the glide," "May be the Boston Dip," and "How is this for style?" The hotel often served as a gathering place for community celebrations. In the 1870s, Lafayette's downtown moved farther west, and one hotel after another was built on the corner of Mount Diablo Boulevard and Moraga Road, a stopping place for stagecoaches. (Above courtesy Lafayette Historical Society; below courtesy Louis L. Stein Jr.)

The Pacific Coast Business Directory from 1867 shows a variety of early Lafayette pioneer businessmen: Lawrence Brown, general merchandise and hotel proprietor; Warren Brown, proprietor of a stage line to Oakland; George Hammett, justice of the peace and butcher; Benjamin Shreve, postmaster and general merchant; Philander Standish, Lafayette Flouring Mill; Hiram Stanage, notary public; and Peter Thomson, blacksmith. Other early settlers, such as Elam Brown, are not mentioned, probably because they were farmers and not commercial businessmen. (Both courtesy Contra Costa County Library.)

## PACIFIC COAST
# BUSINESS DIRECTORY
### FOR 1867:

CONTAINING THE

### NAME AND POST OFFICE ADDRESS OF EACH MERCHANT, MANUFACTURER AND PROFESSIONAL

RESIDING IN

STATES OF CALIFORNIA, OREGON, AND NEVADA ; THE TERRITORIES OF WASHINGTON, IDAHO, MONTANA, AND UTAH; AND THE COLONY OF BRITISH COLUMBIA.

ALSO,

## GAZETTEER OF THE COUNTIES, CITIES AND TOWNS,

AND

### An Exhibit of the Resources of the Pacific Coast.

---

**Lafayette**, Contra Costa Co, P O, 11 miles s w of Martinez

BROWN L M, general merchant and hotel proprietor

Brown Warren, proptr stage line to Oakland, Martinez, etc

Connor J W, wheelwright

HAMMETT GEORGE W, Justice of the Peace and butcher

Molter C, harness maker

SHREVE B, agent Bamber & Co's Express, postmaster and general merchant

STANDISH P H, Lafayette Flouring Mills

Stanage H M, Notary Public

Thomson Peter, blacksmith

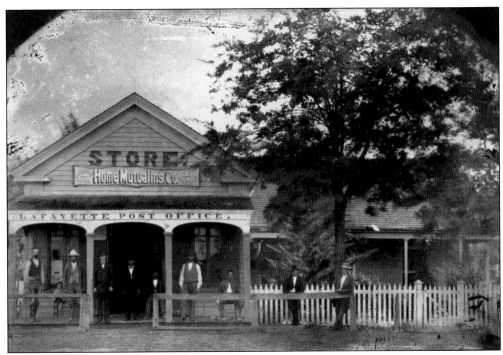

*You Can not expect the best of flour, where their is adobe in the wheat, mixed all thing*

Grist No. 5 116

Lafayette Mills. Oct. 8th 1867.

**RECEIVED:**

20 Sacks 1902 lbs. of Wheat,

16 Ex. Flour Sacks + 1 Burlap

37.

Mrs. Doan,                                    Dr.

To Grinding 1902 lbs. of Wheat, @ ½ c. $ 9,51

**RETURN:**

Flour, — 13 sks. lbs.

Bran, — 10 "

Middlings, — 2 "

Screen, — 1 "

Empty 10 "

½ sk adobe 3 6 — "

Loss, — 1 "

37

To          Flour Sacks.

½ sk Adobe          .25

9,26

Received Payment,          1

Coffin and Standish

By J. McDaly

In 1853, Elam Brown purchased a grist stone to build a mill. Prior to this, farmers had to travel to San Jose to have grain ground into flour, a trip that took a week. Brown's mill was located near the Plaza Park and later was sold to John Standish, who operated it with his son Philander. An 1867 bill from Standish for milling wheat is pictured here. (Courtesy Lafayette Historical Society.)

Benjamin Shreve operated the Pioneer Store from 1857 to 1887 and served as the postmaster for those years. In 1857, when a post office permit was granted, he named the town La Fayette, a spelling that was officially changed to Lafayette in 1932. No known picture exists of Shreve but the center figure, with a mustache, may be him. (Courtesy Horace Shreve.)

An 1878 bill of sale from Benjamin Shreve is made out to Mr. Houghf (Hough). Shreve maintained the first post office in the general store for 24 years. He first chose the name Centerville for the settlement but was informed that it had been already used for another town. Because of his admiration for the French marquis and because many of the early settlers had come from other communities named after the French general, La Fayette was chosen. (Courtesy Benjamin Shreve.)

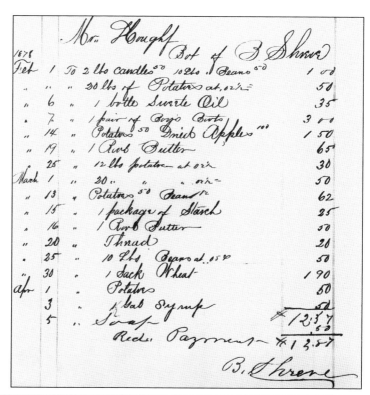

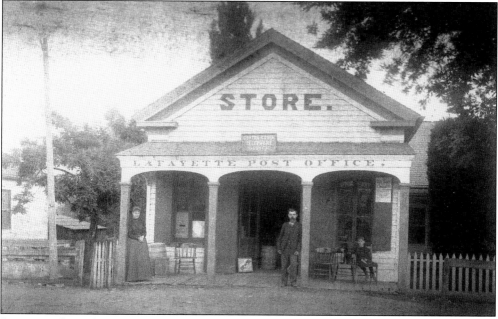

Benjamin Shreve built and owned this store in the 1850s. In 1890, when it was owned by Shreve's son Milton, it housed the post office and the Contra Costa telephone office. There was only one phone in town, located in the store, when phone service began in 1881. To deliver a phone message, a youngster would be paid a nickel. Pictured are, from left to right, Flora Shreve, Milton, and their daughter Ada. (Courtesy Milton Shreve.)

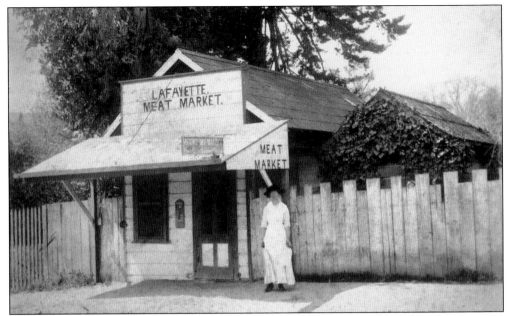

The Lafayette Meat Market is pictured here in 1904. There was no refrigeration, but the meat market had an icebox. One steer a week would be slaughtered in the winter and six or eight a week in the summer so that fresh meat would be available. May Daley Starks stands in front of the Lafayette Meat Market, owned by her family. (Courtesy Louis L. Stein Jr.)

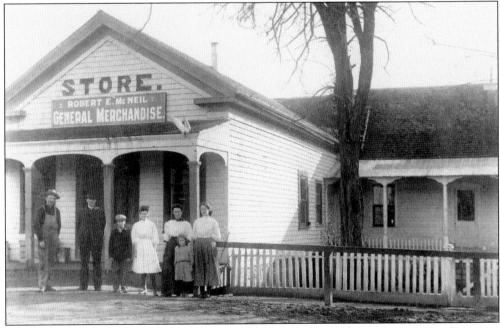

The Pioneer Store was owned by the McNeil family from 1902 to 1935. In 1906, the San Francisco earthquake knocked jars from the store shelves and caused a breakfront china cupboard to fall, breaking Gertrude McNeil's prized china. Pictured are, from left to right, Bob Robinson (handyman), Robert Elam McNeil, William McNeil, Alice McNeil, Gertrude Thomson McNeil, Bertha ?, and Ruth McNeil. (Courtesy Alice McNeil Russi.)

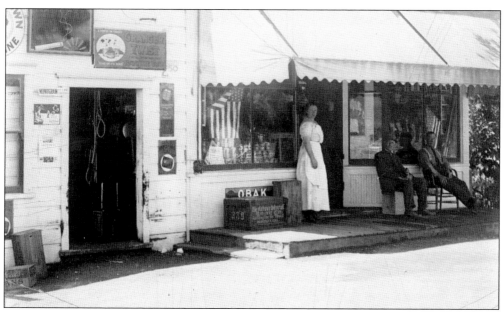

Gertrude McNeil stands in the doorway of the Pioneer Store (c. 1920), where items such as drugs, groceries, dry goods, harnesses, shoes, hardware, fuels (gasoline, stove oil, and coal), and barrels of syrup and molasses were always in stock. Merchandise was shipped via the Southern Pacific Railway to Walnut Creek, picked up by wagon, and brought to Lafayette. When the Sacramento Northern was built, freight was left at the Lafayette station. Perishable items and groceries were hauled from Oakland. Pictured below are, from left to right, Robert Elam McNeil; his wife, Gertrude Thomson McNeil; Gertrude Thomson Russi; Dorothy Russi; Alice McNeil; and William McNeil (little boy). (Both courtesy Alice McNeil Russi.)

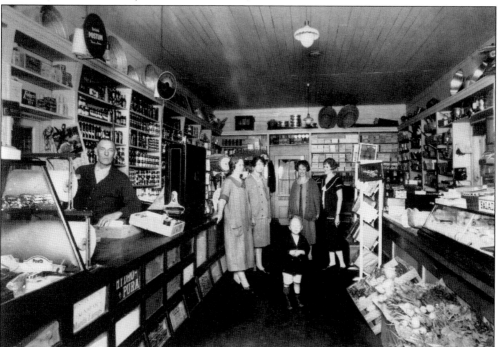

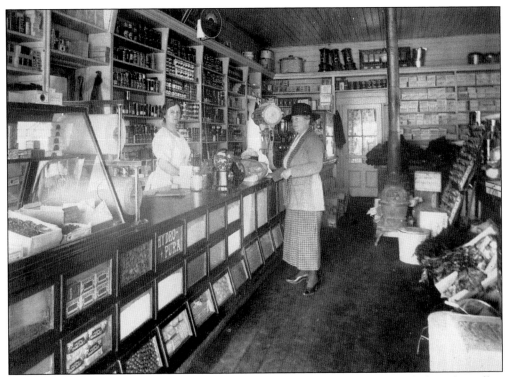

Gertrude McNeil waits on Mrs. Harry Woodridge. The store had a showcase with thread, needles, ribbons, sewing supplies, and fabrics. There were hoes, pitchforks, scythes, and horse collars, and postal boxes for mail. In another showcase were tobacco and pipes. Also sold in the store were coffee, tea, sugar, flour, and crackers. The Pioneer Store's look changed after its sale to Hinckley and Emmert in 1935. The store provided people with a place to gather. Horseshoes, baseball, foot races, wrestling, and listening to the gramophone were activities popular in the community. Occasionally a lone bagpiper would appear in kilt and regalia and march around the plaza. No one knew who the piper was, but the community welcomed him. (Above courtesy Alice McNeil Russi; below courtesy Hinckley family.)

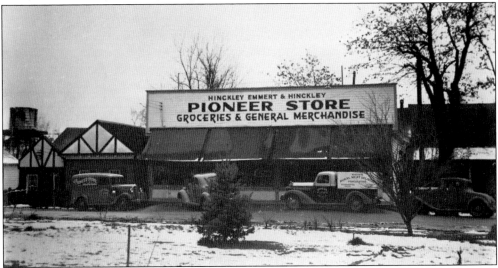

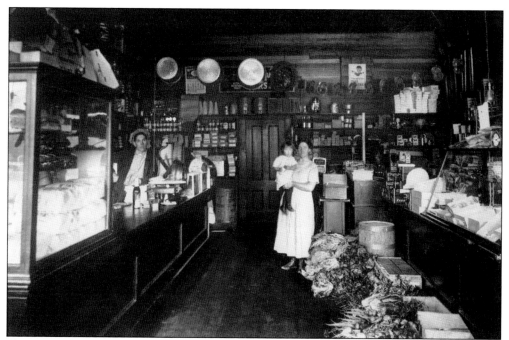

Eleanor Starks Meyers remembers the Starks Store in the 1920s as containing "shirts and jeans, raincoats, and a few drugs. Pocket knives went along with the hardware. We had pots and pans and household goods, and a grocery store." An apartment was added to the back of the store, where the family lived. Pictured are, from left to right, Leroy Starks, Eleanor Starks (child), and May Daley Starks. (Courtesy Louis L. Stein Jr.)

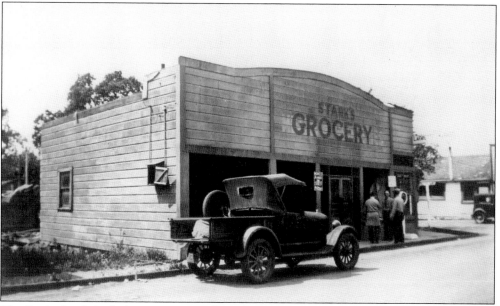

The Starks family built three stores in Lafayette: one on Moraga Road and two on Mount Diablo Boulevard. This photograph shows the last store on Mount Diablo Boulevard in 1935, while it was being remodeled to become Mickey Meyers's Groceteria. Standing by the scales are Lewis Starks and Guy Johnson. (Courtesy Eleanor Meyers.)

A paid invoice from Peter Thomson's blacksmith shop in December 1862 shows charges to John Slitz (misspelled as Slitts) and James McGee for painting and sharpening plows. The blacksmith made many of the metal tools needed by local farmers as well as horseshoes for the town's horses. Thomson's anvil is on display in the Lafayette Library. (Courtesy Louis L. Stein Jr.)

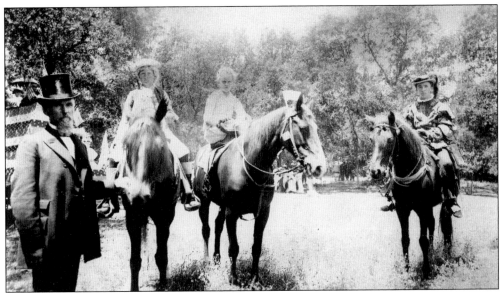

Peter Thomson is pictured at left in the top hat on the Fourth of July in 1888. Thomson enjoyed celebrating holidays and special occasions. To commemorate the end of the Civil War, he filled an opening in his anvil with gunpowder and shot it off so many times that the anvil had to be patched. On the horses are, from left to right, Milton Moore, unidentified, and Goy Simpson. (Courtesy Horace Shreve.)

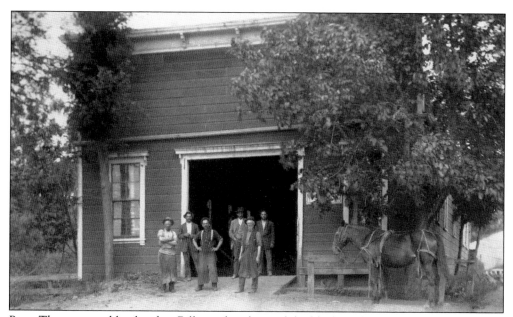

Peter Thomson and his brother Bill stand in front of the blacksmith shop. Thomson was born in Canada and came to California by ship in 1859. He worked as a journeyman in John Elston's blacksmith shop for four years. Also pictured are Will Gerow and Henry Crow. (Courtesy Contra Costa County Historical Society.)

A receipt from 1895 shows services from Peter Thomson for work on George Gray's hay press. Thomson repaired the press chain, replaced bolts, and welded parts of the press, a crucial piece of farm equipment for early farmers to bale and store hay for their livestock. (Courtesy Contra Costa County Historical Society.)

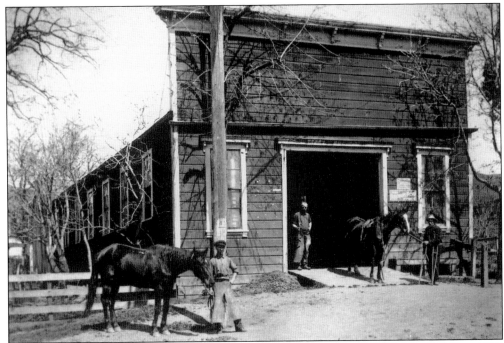

Peter Thompson owned this blacksmith shop, located across from Plaza Park, from 1863 to 1914; his home was nearby. William Thomson is seen in the doorway, and Joe Hunt is on crutches. Old Bill, an ex-cavalry horse of J. E. Daley, is visible in the photograph on the left. (Courtesy Louis L. Stein Jr.)

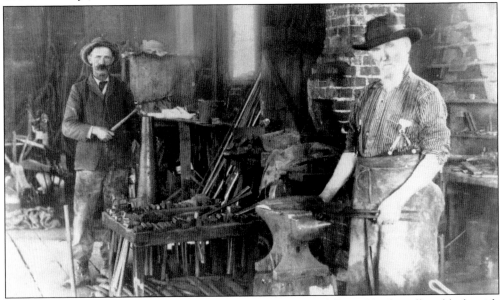

A newspaper article from the time describes Peter Thomson as follows: "As the village blacksmith he was ever jovial, of a kindly nature and ever willing to extend a helping hand to his fellow man in adversity. His friends are legion and he is held in highest esteem by his fellow citizens of Contra Costa County." Napoleon Bonaparte Buckingham is pictured to the left of Peter Thomson. (Courtesy Alice McNeil Russi.)

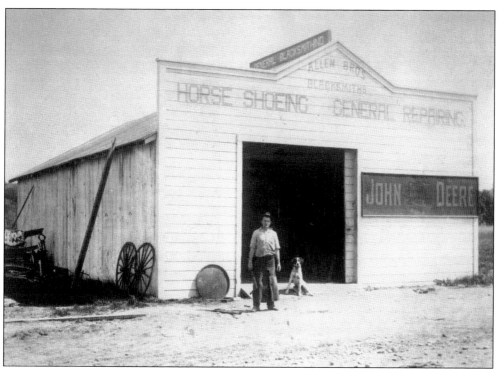

The Allen Brothers blacksmith shop was located on Moraga Road in the early 1900s. Ed Allen, seen here, was a descendent of Margaret Allen, who was Elam Brown's second wife. Ed was the son of Charles Allen, who had come from Canada in 1884. As the town grew, there was a need for additional blacksmith services. (Courtesy Contra Costa County Historical Society.)

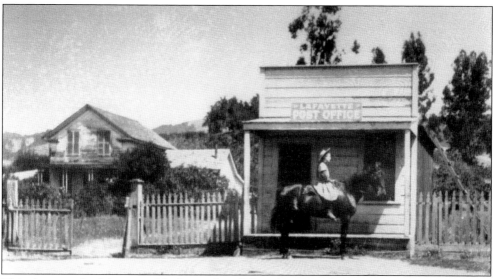

This photograph of the second Lafayette Post Office shows Pearl Van Meter, daughter of Carrie Van Meter, in front of the post office on her horse Pegasus around 1900. Children in the early town often rode their horses from place to place. The Van Meter home is pictured at left. (Courtesy Alice McNeil Russi.)

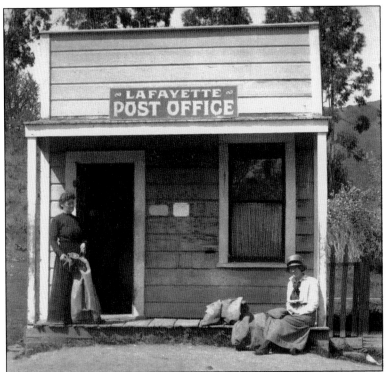

This post office was moved from its first location in the Pioneer Store to this building, located on Mount Diablo Boulevard. Carrie Van Meter was postmistress here from 1904 to 1927. Pictured on the porch are Carrie Van Meter and daughter Pearl (seated). Home mail delivery would not be available for many more years, so it was picked up at the post office. (Courtesy Contra Costa County Library.)

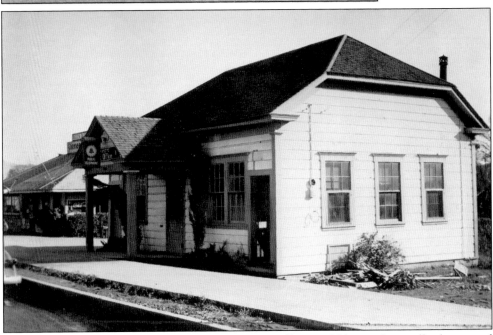

This building housed the telephone exchange, post office, and library. Originally the second grammar school building in Lafayette, it was moved to Mount Diablo Boulevard about 1928. The first subscription library was organized in Lafayette in 1860, and in 1915, the first county library branch was started in the corner of the post office, where Carrie Van Meter was custodian of 60 books. (Courtesy Louis L. Stein Jr.)

# *Three*

# FARMING LIFE

The land of Lafayette was both rolling foothills and fertile valleys. Trees and dense undergrowth grew near the various streams, but most of the area was open with native grasses. The soil and weather were conducive to farming.

For the settlers from back East, the similarity of the four seasons must have been striking. There was rare snow in winter. The winters saw rain that replenished the soil and warm-enough weather that grasses and crops grew. Cattle could graze and did not have to be fed, providing a huge savings to farmers. There was little, if any, rain in the summer months. The grasses turned from green to light brown in summer not fall.

Hot summers helped grow crops but also held the threat of wildfires. The fog added a cooling effect to summer evenings, and humidity remained relatively low all year. Planting took place in both winter and spring. Records show that wheat, barley, and oats were sown anywhere from late November to March. Haying started in June and continued for some weeks depending on the weather.

When Elam Brown purchased his land in 1848 from William Leidesdorff, the price included 300 cows. Cattle provided milk, butter, meat, hides, and cash. Brown also grew wheat and barley.

Wheat was an important commodity for the entire county from the late 1860s to the end of the century. People streamed into California for the Gold Rush and then settled on the land as their fortunes waned. Roads expanded, and the economy boomed to handle the farming products and the influx of people. Grain hauled to Pacheco and Port Costa was shipped all over the world.

According to Elam Brown's son Thomas, about two thirds of the cultivated land was devoted to wheat in 1875. The other third included barley, plots of vegetables, vineyards, and fruit, olive, and almond orchards.

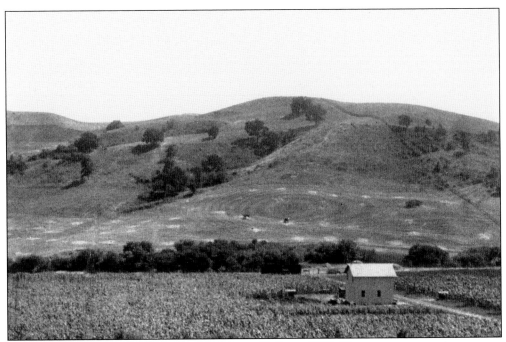

This farm is the Allen Wright property in Happy Valley in 1908. The crop appears to be corn, an unusual harvest in Contra Costa County. Note the circular plowing pattern seen on the slope. In general, the flatter lands in Lafayette were used for crops and grains, while the cattle were left to roam the steeper hills. (Courtesy Allen Wright.)

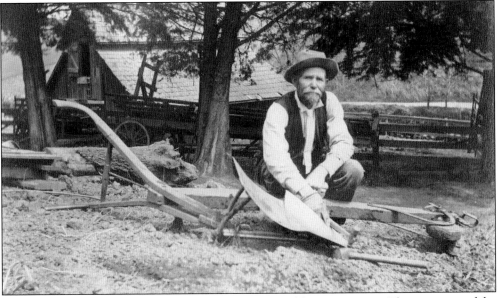

A farmer is pictured here with a plow, an integral piece of farm equipment. The invention of the wooden plow in the late 1700s enabled farmers to produce more crops with less labor. The end of the plow was attached to a team of horses or oxen, the coulter sliced a furrow in the ground, and the moldboard lifted and turned the soil. (Courtesy McNeil family.)

The Louis L. Stein Sr. ranch, pictured here in 1920, was bought in 1915 on Springbrook Road, just east of the present Acalanes High School. The ranch had 500 chickens with a brooder house to raise chicks. Each week, six cases of eggs were hauled in their old Dodge and trailer over Old Tunnel Road to the Wood Shed, a restaurant on University Avenue at Shattuck Avenue in Berkeley. (Courtesy Louis L. Stein Jr.)

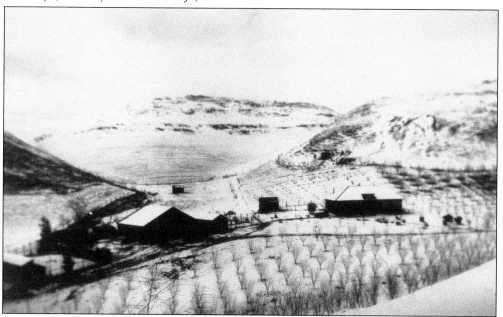

The Stein ranch had a man-made redwood plume to carry water from a well to the cattle. There were 15 acres of orchards, where the Stein grew almonds, peaches, apricots, walnuts, prunes, apples (including a winter banana apple), and pears, which were put in cold storage in Oakland and sold for $3 a box at Christmastime. Strawberries and tomatoes were also grown. (Courtesy Louis L. Stein Jr.)

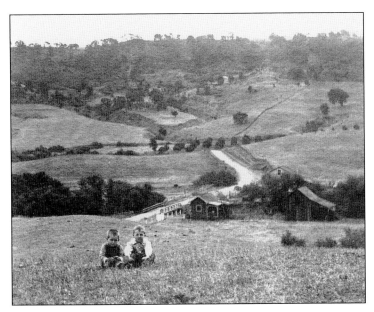

Alton and Lawrence Hollenbeck sit in a pasture on the Hollenbeck ranch, c. 1910. Children, especially boys, were expected to help with the chores of the ranch. Often they did not attend school during harvest time. (Courtesy Evelyn Cummings.)

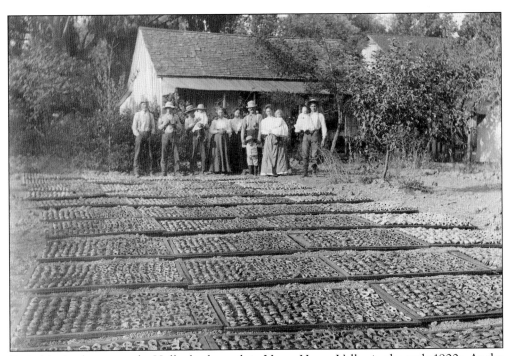

Fruit dries in the sun on the Hollenbeck ranch in Upper Happy Valley in the early 1900s. As the family lines up for this photograph, imagine the pride for all the hard work of picking the fruit, splitting it, and drying it. Longs periods of hot summer days with no rain made perfect conditions for growing and drying fruit. (Courtesy Evelyn Cummings.)

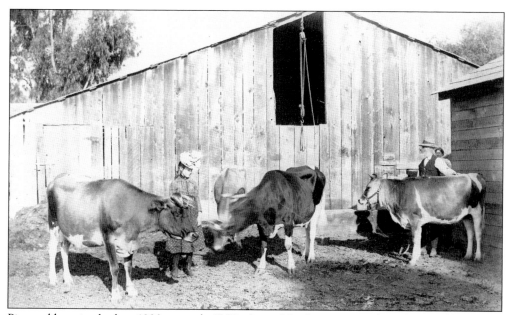

Pictured here in the late 1800s or early 1900s, Jenny Hatch, wearing a fancy hat, and her father tend to their cows on the Hatch ranch in Upper Happy Valley. They kept a typical barn with a pulley for hauling hay bales up to the rafters for storage. Many farmers made their own butter and cheese from the cows' milk. (Courtesy Evelyn Cummings.)

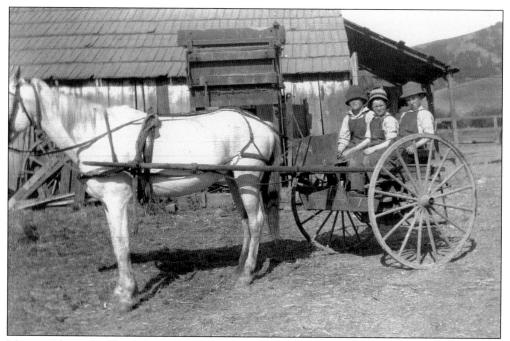

Marion Alexander Flood, Raymond Bayard Flood, and Earl Edward Flood ride in a horse cart around 1915. All three wear identical bib overalls. Farm children became accustomed to farm animals and equipment at an early age. (Courtesy Nancy Flood.)

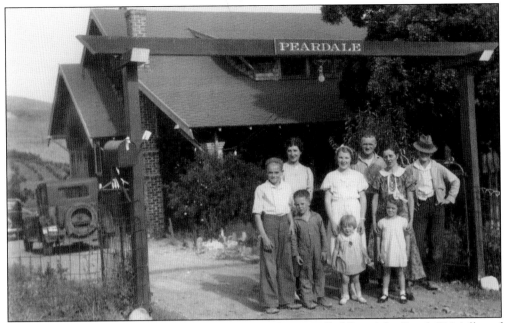

The Malley family poses in front of their summer home, called Peardale. Frank T. Malley of Oakland purchased the land as a ranch in 1910. It was east of Upper Happy Valley Road, south of Lower Happy Valley Road, and north of Los Arabis Drive. Pictured here are, from left to right, (first row) brothers and sisters Chuck, Jack, Patricia, and Marianne Malley (Millette); (second row) unidentified, unidentified, parents Lucille and Charles Malley, and Frank Malley. (Courtesy Marianne Millette.)

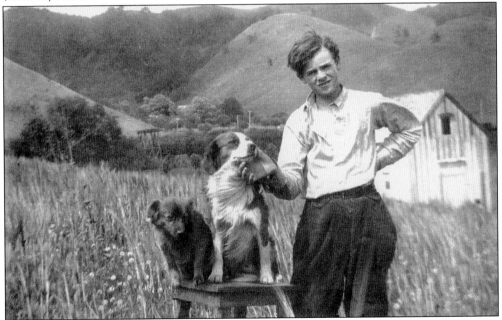

Charles Malley is pictured on the Malley ranch with his dogs. The ranch had pears, peaches, walnuts, and a grape vineyard. Charles's father later subdivided the area of their ranch, which became known as Peardale. (Courtesy Marianne Millette.)

Nat Martino picks plums on his Spring Valley ranch in 1919. He had a big barn and 90 acres. On 10 of those acres, he grew hay to feed his five or six cows. He grew plums, small apples, peaches, and grapes, but the pears grew the best of all. He delivered the produce to wholesale markets in Oakland in his Model T truck. (Courtesy Nat Martino.)

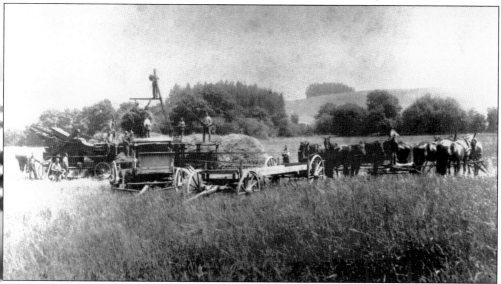

Edward Dunn's thrasher was used in Lafayette for harvesting hay, and extra crews of men were hired from the surrounding area during harvest time. James Bickerstaff, Margaret Bickerstaff Rosenberg's father, is standing on top of the crane. (Courtesy Margaret Bickerstaff Rosenberg.)

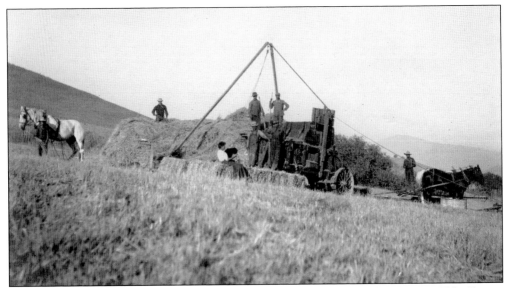

In summer, men would be hired to use this early hay press. In his 1898 diary, Henry Toler Brown noted that hay balers came from Henry Crow's ranch and started pressing hay on July 19. They pressed 108 bales and returned on August 3 for more work. Brown sold the hay throughout the winter to clients in Oakland, a good source of cash for him. (Courtesy Lafayette Historical Society.)

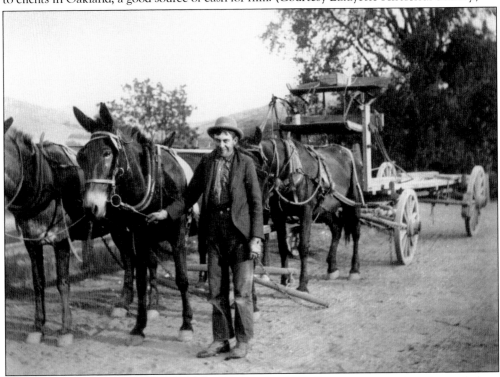

A hay wagon with mules sits on Happy Valley Road in 1901. Because wagons, buggies, and plows all required maintenance, the blacksmith shop was an important addition to the community. Blacksmiths were resourceful with the metal they had on hand and were able to make and repair many different types of tools and conveyances. (Courtesy Katherine McVean.)

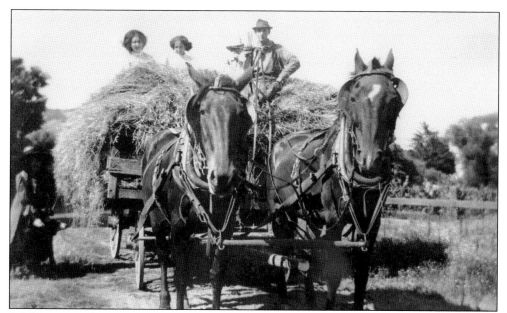

Sybil Brown and Pearl Christians ride on a hay load to the barn on Elam Brown's ranch around 1910. At this time, Sybil's father, Henry Toler Brown, was living in Elam's home on Hough Avenue. The width of this hay wagon explains why only one wagon at a time could pass through the Old Tunnel, while two cars could easily pass each other. (Courtesy Sybil Brown Wilkinson.)

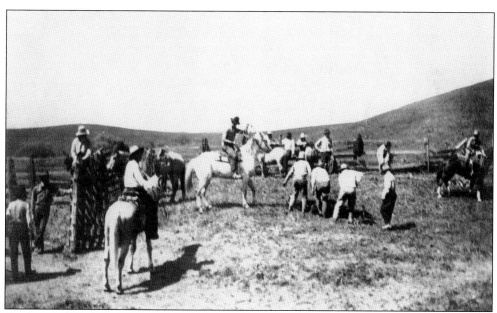

Cattle were branded on the property at the end of Brown Avenue in 1911. In the early days, there were no fences and cattle roamed the hills. When rounded up, the brands allowed the stock to be separated by owner. Brands were registered with the county and were a source of pride for the ranchers. (Courtesy Kenneth Brown.)

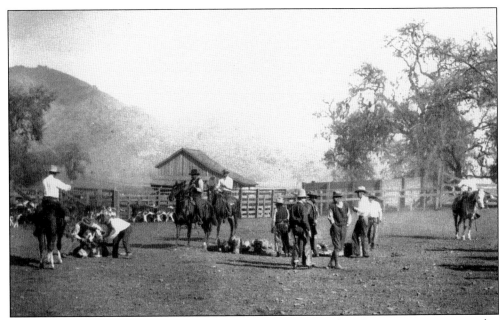

Here cattle are being branded in 1924. On the right is Dr. Robert Root, veterinarian, on his horse. Ken Brown, son of Henry Toler Brown, is on the horse at the extreme left. John Morss, who often led the cattle drive, is bending over the calf. Below, cattle are driven down Mount Diablo Boulevard in 1921. They would be taken through the Old Tunnel or up Fish Ranch Road and then through Berkeley on the way to Butchertown in Emeryville. It was an all-day ride, and there was no water on the route. William McNeil told about another cattle drive in Lafayette in 1938. John Morss' son, Flood Morss; the Brockhursts; and the Browns drove 200 cattle from Briones Valley through Lafayette to Alamo. It was the last cattle drive through Lafayette. (Above courtesy Kenneth Brown; below courtesy Clarence Brown.)

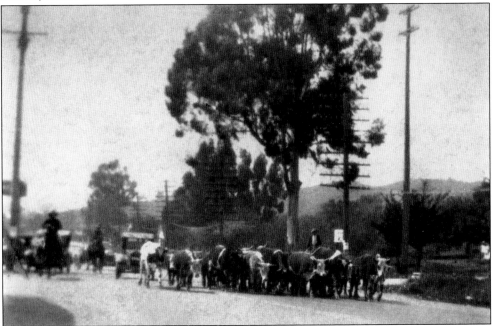

*Four*

# THE COMMUNITY GROWS

As the population of Lafayette grew, so did the need for additional businesses and services. The citizens of the early settlement were willing to financially support education, cemeteries, churches, and town government. In 1868, Lafayette citizens passed a tax measure to build a new grammar school. A community fund-raiser raised money to purchase a school bell for the new school. This school served the students of Lafayette until 1893, when the third schoolhouse was built using money from a $2,000 tax measure. When the fourth schoolhouse was built in 1927, the old schoolhouse was sold to the Methodist Church to be used as a sanctuary and parsonage.

The earliest recorded burial in Lafayette was in 1854. As there was no official cemetery at that time, Medford Gorham allowed a young girl to be buried on his land at the east end of town. By 1874, more burials had taken place on the same site, causing Gorham to sell the acreage to the community to establish a cemetery. In 1937, the Alamo-Lafayette Cemetery District was established, supported by taxes from the community.

On November 11, 1911, members of the Lafayette Improvement Club met for the first time and decided to support the building of a permanent meeting place for their organization. It was estimated that the cost of a piece of property would be $490, and various ways to raise money were explored. Frank and Rosa Ghiglione made a generous offer and deeded a piece of property and $200 to the club to help construct the building. Fund-raising in the form of dances and suppers raised more money, and stock certificates for shares in the Lafayette Improvement Corporation Club were also sold to raise the needed capital. The Town Hall officially opened on May 1, 1914.

Additional stores and other businesses were built, especially along Mount Diablo Boulevard, which served as the main road between Oakland or Berkeley and Walnut Creek. Restaurants, bars, and real estate offices joined groceries and drugstores in serving the residents of the growing community.

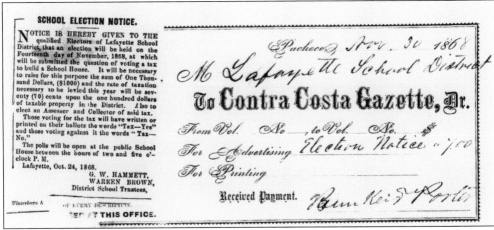

This newspaper notice announces an election to levy a tax for a new school in Lafayette in 1868. The tax would be 70¢ per $100 of taxable property to raise $1,000 for the project. The measure passed 16-3, with only men allowed to vote in the election. (Courtesy Contra Costa County Historical Society.)

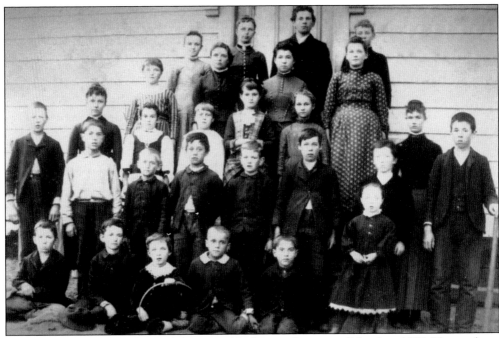

A photograph shows students of the second Lafayette Grammar School in 1887. The students are, from left to right, (first row) ? Crow, Edgar Thomson, Guy Simpson, ? Doré, ? Doré, and ? Isaacs; (second row) ? Crow, Ray Doré, Frank Puck, James Gerow, Fred Thomson, Henry Crow, ? Mullikin, and Jack Dunn; (third row) Grace Stanage, Ida Bradley, Carrie Crow, Ethel Thomson, Nellie Thorn, and Edith Thorn; (fourth row) Annie Devlin, Hattie Isaacs, Hannah Dunn, and Sarah Devlin; (fifth row) Harriet Thomson, Margaret "Jennie" Bickerstaff, Frank Thomson, and Belle Bradley. The teacher was Emma Miller. (Courtesy Margaret Bickerstaff Rosenberg.)

# A GRAND ENTERTAINMENT
## AT LAFAYETTE.

A pleasing Entertainment will be given by the pupils of the LAFAY-ETTE SCHOOL on

## Saturday Ev'ng, Dec. 2d,

When the Performance will commence with the Amusing Operetta, entitled,

## Grandma's Birthday.

| | |
|---|---|
| Grandma | Edith Bradley |
| Maud | Mabel Boardman |
| Kate | Gertie Thomson |
| May | Leeta Isaacs |
| Carrie | Nellie Boardman |
| Ella | Nettie Wilson |
| Jennie | Annie Thomson |
| Claire | Jennie Bickerstaff |
| Lyda | Mintie Gerow |
| Eva | Hattie Gerow |

### INTERMISSION OF TEN MINUTES.

To be Followed by the Domestic Drama of

## THE LAST LOAF.

| | |
|---|---|
| Mark Ashton | Wallace Jones |
| Kate Ashton | Clara Hunsaker |
| Lilly Ashton | Maggie McNeil |
| Caleb Hanson | William Bradley |
| Harry Hanson | George Bradley |
| Tom Chubbs | William Thomson |
| Patty Jones | Jennie Dunn |
| Dick Bustle | William Hough |

The whole concluding with the Farce of

## WANTED, A MALE COOK.

The Doors will open at 6 o'clock P. M.   Exercises to begin promptly at 7.

## Admission     -     -     -     -     50 Cents
CHILDREN ..................................... 25 Cents.

Proceeds to be used to PURCHASE A BELL.

**N. B.—If Rain prevents giving the Entertainment, it will be Postponed until WEDNESDAY EVENING, DECEMBER 6th.**

News. Print, Martinez          **EMMA MILLER, Teacher.**

---

After the second school was constructed, a school bell was needed. In December 1882, a fundraiser was held to raise money for a new bell with entertainment provided by the students of the school. Admission was 50¢ for adults and 25¢ for children. There were three parts to the evening's entertainment: "An amusing operetta, a domestic drama, and a farce." There was even a rainout date provided. Many children of the pioneer families are listed in the program, including Margaret "Jennie" Bickerstaff; Gertrude, William, and Nellie Thomson; Minnie and Hattie Gerow; Clara Hunsaker; Maggie O'Neil; and William Hough. (Courtesy Alice McNeil Russi.)

Pictured here is a handwritten receipt from the Pioneer Store for school supplies, which were purchased in April 1885 from Benjamin Shreve. He served as the town's first schoolteacher, instructing 12 students during the winter of 1853–1854. He built the Pioneer Store, ran a hotel, and farmed 250 acres. He became the first postmaster, a justice of the peace, and a member of the town school board. (Courtesy Contra Costa County Historical Society.)

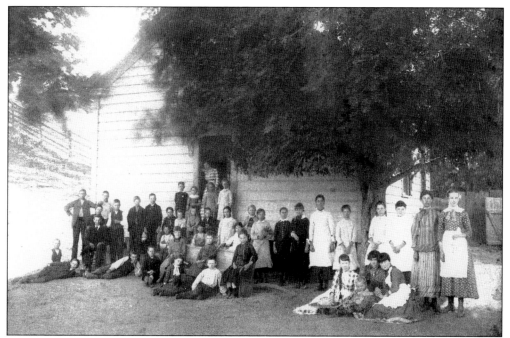

Students are pictured c. 1888 at the second schoolhouse on Moraga Road, where the Methodist church is located today. Margaret "Jennie" Bickerstaff, on the far right wearing the apron, graduated from this school in 1888. Susie Dunn, teacher, stands in the door to the schoolroom. This building was later moved to Mount Diablo Boulevard and became the library, post office, and telephone exchange office. (Courtesy Alice McNeil Russi.)

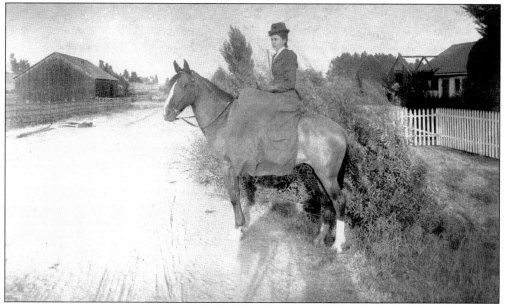

Margaret Bickerstaff, seen c. 1892, rode her horse Topsy to her teaching jobs in Lafayette and Moraga. Because of the long skirts that women wore, she rode her horse sidesaddle. Passing through the fields of local farmers, it was necessary to dismount and remount several times to open and close gates, no doubt a difficult task in long skirts. (Courtesy Margaret Bickerstaff Rosenberg.)

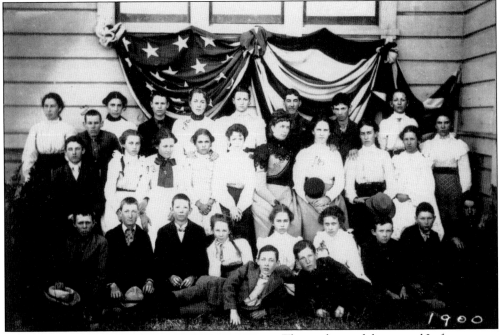

The students of the second Lafayette Grammar School are pictured in this 1900 photograph. From left to right are (first row) unidentified and unidentified; (second row) Buck Crow, Herb Daley, unidentified, unidentified, Edna Shreve, Beatrice Sweet, unidentified, and Frank Hodges; (third row) unidentified, unidentified, Edna Lamp, unidentified, unidentified, teacher Margaret Bickerstaff, Trudy Thomson, unidentified, unidentified, and unidentified; (fourth row) unidentified, Lester Yost, Lillian Doré, Sumner Hodges, Ida Lamp, unidentified, unidentified, unidentified, and unidentified. (Courtesy Louis L. Stein Jr.)

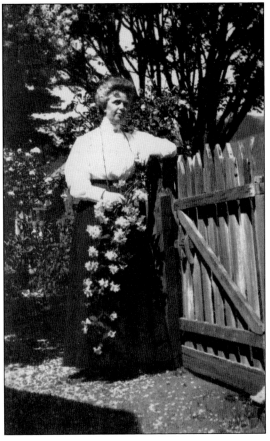

Around 1910, Margaret Bickerstaff stands by the gate in the garden of her home in Lafayette, where she lived for 85 years. She helped plant this garden, including the redwood tree seen to the left behind the house. She married Stephen Dewing when she was 46 and helped to raise his children. Long after he died, she married William Rosenberg. She had no children of her own. (Courtesy Margaret Rosenberg Bickerstaff.)

The program and graduation announcement for the members of the Lafayette Grammar School class of 1921 includes names of the children of many longtime Lafayette families: Ermina and Delmar Mullikin, August Schutt, Earl Flood, Ida Michaut, and Alton Hollenbeck. Evelyn Hollenbeck, Alton's sister, graduated from Lafayette School in June 1926. The Hollenbecks, a farming family, lived in Happy Valley. The seal of the State of California is visible at the top of her diploma of graduation. (Right courtesy Evelyn Cummings; below courtesy Contra Costa County Historical Society.)

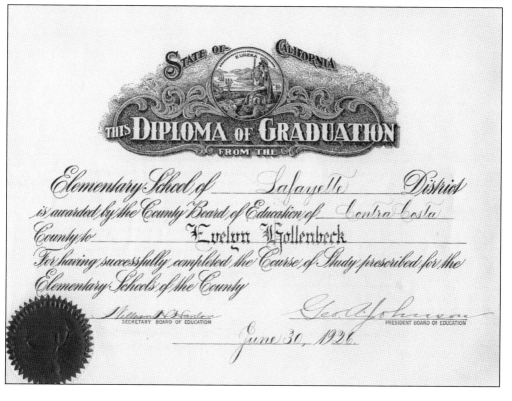

*Lafayette School*  *Class of 1921*

Graduates.
Ermina Mullikin
Delmar Mullikin
Edward Rowland
August Schutt
Arthur Palmer
Earl Flood
Ida Michaut
Bernice Oliveira
Alton Hollenbeck
Melvin Williamson
Charles Rathovich
Joe Lucas

STATE OF CALIFORNIA
EUREKA

THIS DIPLOMA OF GRADUATION
FROM THE

Elementary School of ___Lafayette___ District is awarded by the County Board of Education of ___Contra Costa___ County to ___Evelyn Hollenbeck___ For having successfully completed the Course of Study prescribed for the Elementary Schools of the County

SECRETARY BOARD OF EDUCATION     PRESIDENT BOARD OF EDUCATION
June 30, 1926

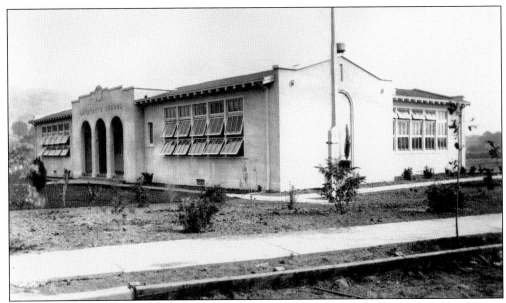

The fourth Lafayette Grammar School, pictured in this 1935 photograph, is located on Moraga Road and School Street. In 1927, when this school was built, the Lafayette School District trustees sold the third schoolhouse and property to the United Methodist Church for the sum of $2,000. (Courtesy Mildred Lloyd.)

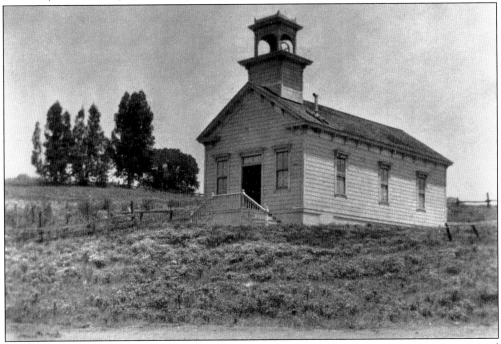

The Good Templar Hall was organized in 1862 to house termperance-movement meetings and was built on a hill at the north side of Plaza Park. The timbers in the building came from the Redwood Canyon. In 1927, the building was sold for $1,500 to Clarence and Freda Brown, who had it torn down and the hill leveled. The timbers were saved and used to build a home on Boyer Circle. (Courtesy Lafayette Historical Society.)

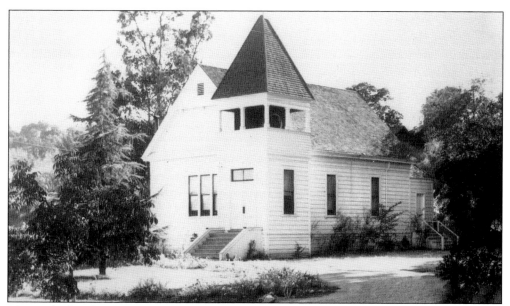

The Methodist church building was originally the third grammar school, constructed in 1893. The church purchased it in 1927 after the "new school" was built across Moraga Road. The building, with its belfry, was used as the church and parsonage. Due to increasing numbers of members, a new parsonage was built in 1940. In 1943, a chapel was constructed. An original school bell remains in the bell tower. On the left is one of two deodar cedar trees planted in 1927 by Gertrude and Robert E. McNeil. Below, members of a 1930s Lafayette United Methodist Church Sunday school class are pictured on the front steps of the church, the same building that is featured on the cover of the book. (Above courtesy Alice McNeil Russi, below courtesy Katherine Schutt.)

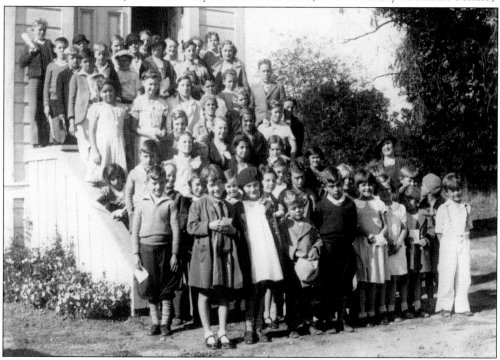

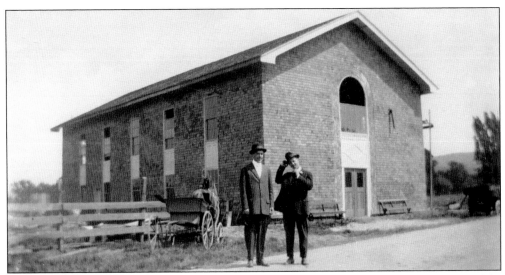

Two visitors from Oakland view the Town Hall building soon after it opened in 1914. Land for the hall, on the corner of School Street and Moraga Road, plus $200 for expenses were given by Frank and Rose Ghiglione. Additional money was raised by the women of the town at dances and midnight suppers in Happy Valley. The men donated their time for constructing the hall. Revelers from Martinez, Berkeley, and Oakland enjoyed dances at the Town Hall, where a springy dance floor delighted partygoers. A Lafayette Improvement Club stock certificate issued in 1935 to Lafayette resident Charles F. Malley is pictured below. (Above courtesy Sybil Brown Wilkinson; below courtesy Marianne Millette.)

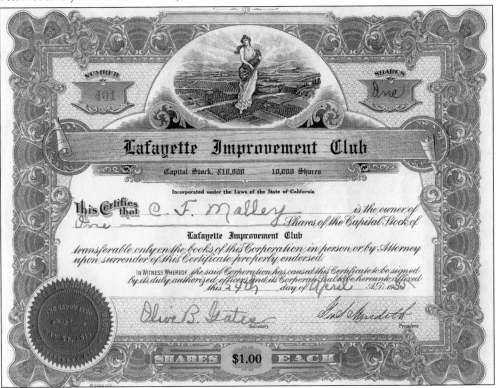

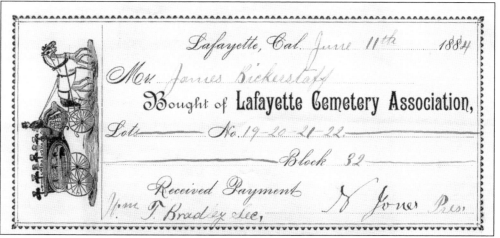

A receipt from the Lafayette Cemetery Association shows the purchase of a cemetery plot by James Bickerstaff in 1884. In 1874, the citizens of Lafayette met for the purpose of forming a corporation to be designated the Cemetery Corporation of Lafayette. Elam Brown was chosen as chairman of the meeting and G. W. Hammett as secretary. After the corporation was formed, land was needed for the cemetery. On October 15, 1874, four and a half acres of land were purchased from W. Medford Gorham for $100. In 1937, the county formed the Alamo-Lafayette Cemetery District. James Bickerstaff and his wife, Delilah, are buried in the Lafayette Cemetery as is their daughter Margaret Bickerstaff Rosenberg and her second husband, William. (Both courtesy Margaret Bickerstaff Rosenberg.)

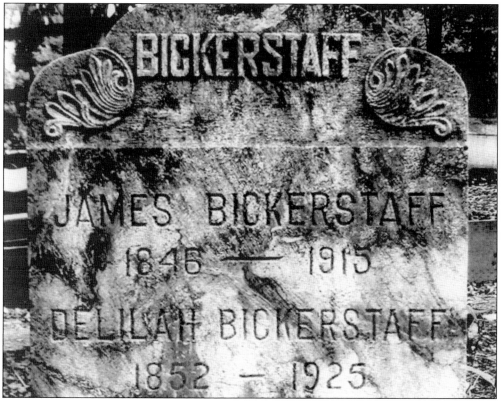

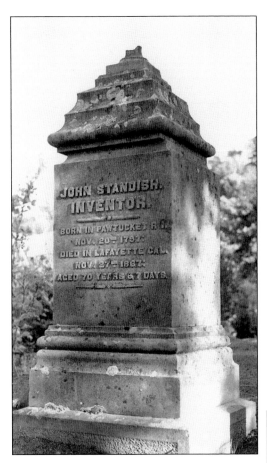

John Standish, born in Rhode Island in 1797, is buried at the Lafayette Cemetery. He purchased and operated the gristmill started by Elam Brown. Standish was a direct descendant of Capt. Miles Standish, who came to America on the *Mayflower* in 1620. He and his son Philander invented the Mayflower steam plow and other farm machinery. (Courtesy *Lafayette Squire*.)

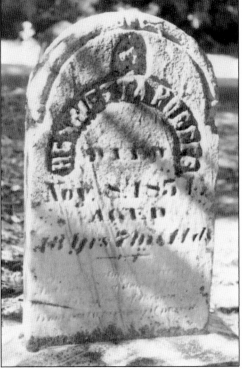

Henrietta Hodges, a 13-year-old girl, was the first recorded burial in the Lafayette Cemetery in 1854. Daughter of David Hodges, an early Lafayette pioneer, Henrietta was one of 14 children in the Hodges family, including two sets of twins. She died of tuberculosis, and the owner of land on the east side of the town, Medford Gorham, agreed to her burial there. (Courtesy Christine Schreiber.)

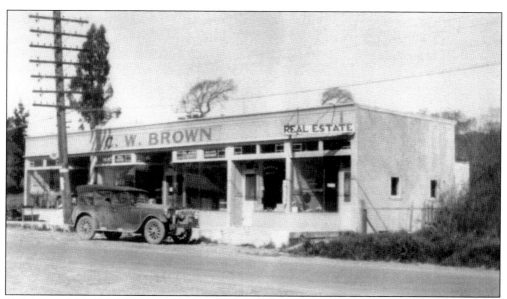

Col. Manuel M. Garrett, a retired army officer, came to Lafayette in 1920 and entered the real estate business. He constructed a building on the north side of Tunnel Road in the center of Lafayette. Seen in this 1928 photograph are Clarence W. Brown's hardware store and Col. Garrett's first real estate office. (Courtesy Katherine Schutt.)

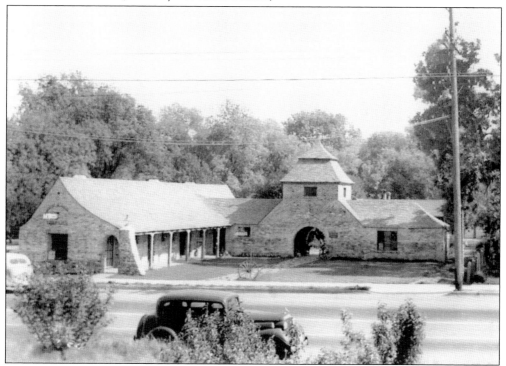

Colonel Garrett constructed this brick building at 3565 Mount Diablo Boulevard in the late 1930s and tried to promote this type of architecture for all the new buildings in Lafayette, but with no success. His second real estate office was located on the left side of the building. (Courtesy Contra Costa County Historical Society.)

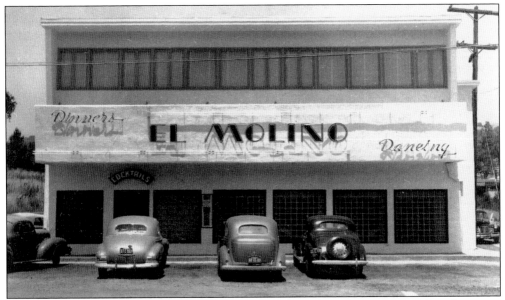

The El Molino Bar and Restaurant, a popular "nightclub" in the 1930s, was located on the corner of Mount Diablo Boulevard and Oak Hill Road. It was later the location of Danny Van Allen's club. Nightclubs in Lafayette were so popular for dining and dancing in the 1930s that Mount Diablo Boulevard was often called "the strip." (Courtesy Eleanor Meyers.)

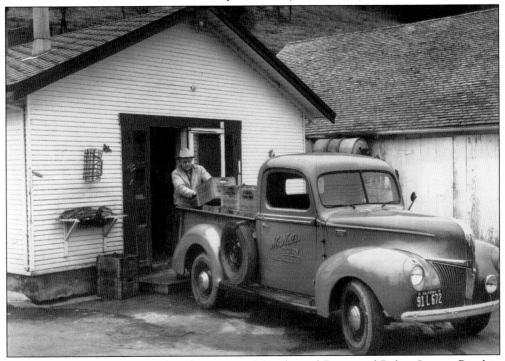

The McNeil Dairy was located at the corner of Beechwood Drive and Reliez Station Road in the 1930s. Stuart McNeil, owner of the dairy, is pictured here loading milk for home delivery. He was the son of Robert McNeil and Gertrude Thomson McNeil, owners of the Pioneer Store. (Courtesy Alice McNeil Russi.)

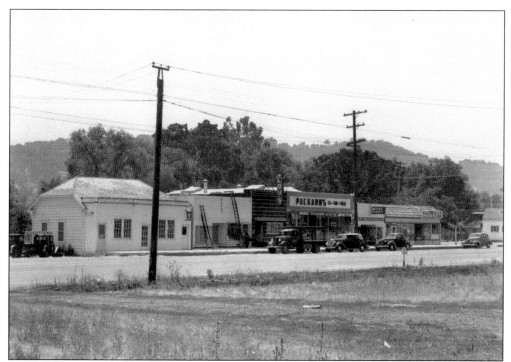

The Lafayette business district in the 1930s was located on Mount Diablo Boulevard. The white building on the left had been the second schoolhouse, moved from Moraga Road, and housed the post office/telephone exchange. Other buildings are, from left to right, Lou Borghesani's bar, Packard's Five and Dime Store, Peter's Emporium, and Mickey Meyers's market on the corner of Hough Avenue. (Courtesy Louis L. Stein Jr.)

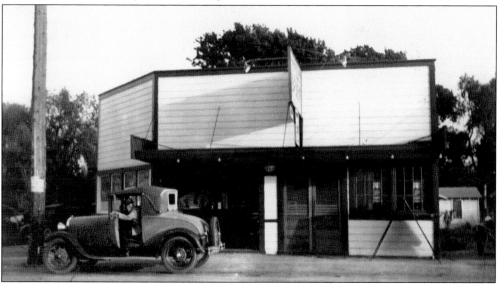

Located on Mount Diablo Boulevard, Lou Borghesani's bar was first called Lafayette Inn and later was changed to Lou's. Anyone riding into the bar on horseback would receive a free drink, and the horse a carrot. This building has also housed Ma Hunt's Kitchen in the 1920s, Lou's Bar in the 1930s, and later the offices of the *Lafayette Sun*. (Courtesy Lou Borghesani.)

This photograph was taken at the grand opening of Lou's Bar on Mount Diablo Boulevard. Pictured are, from left to right, Jack Connley, Babe Borghesani (Lou's wife), Henry Hadapp (a barber), and Earl Ross; (second row) Bill Rupp (a butcher in Mickey Meyers' store). In the 1930s, both men and women dressed up when they went out on the town, even wearing hats. (Courtesy Lou Borghesani.)

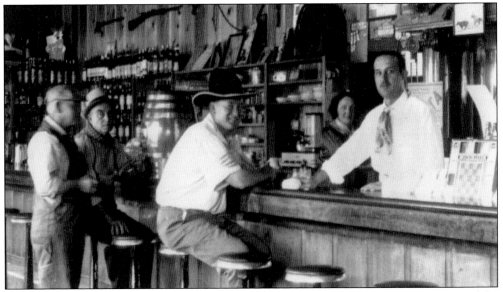

The interior of Lou Borghesani's first bar is pictured in 1934. The popular owner was one of the organizers of the horse show (1935–1944) and was an active participant in city life. At the bar are, from left to right, Dale Wishmeyer, Bert Fiske, and Pat Curran. Lou and his wife, Babe, are behind the bar. (Courtesy Lou Borghesani.)

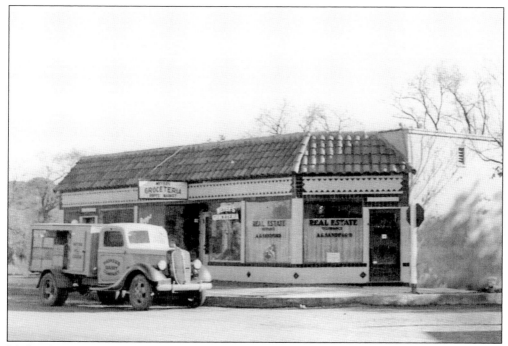

Mickey Meyers's Groceteria and a real estate office are shown at the corner of Mount Diablo Boulevard and Hough Avenue (now called Lafayette Circle) in the late 1930s. A delivery truck used by the grocery is parked in front of the store. (Courtesy Contra Costa County Historical Society.)

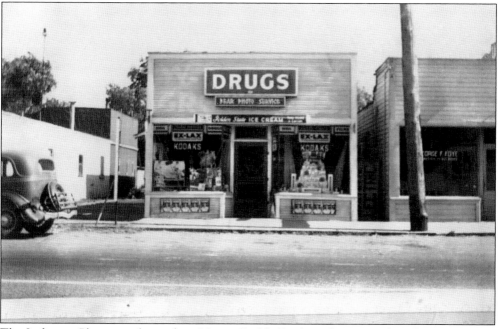

The Lafayette Pharmacy, located on Mount Diablo Boulevard, was purchased in 1935 by M. H. Stanley, who owned it about 15 years. Stanley's wife worked there for a few years, and Louis Winkler was the pharmacist. Good tuna sandwiches and fresh apple pie were available every day, as were prescriptions, medicine, and other notions. (Courtesy M. H. Stanley family.)

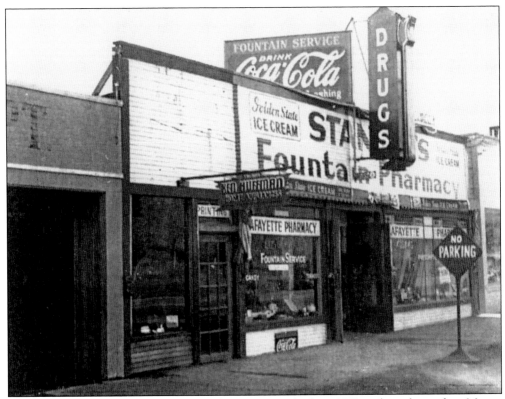

Stan's Fountain and Pharmacy, another drugstore, was built in 1933 and was located on Mount Diablo Boulevard. Fountain service and ice cream were available in the store. Ken Huffman's Appliance Store and the fire department building are at left in this 1937 photograph. (Courtesy Contra Costa County Historical Society.)

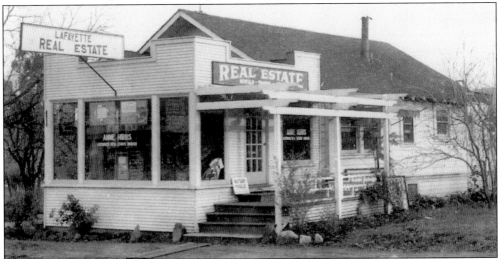

The Hibbs Real Estate Office (c. 1935) was located on Mount Diablo Boulevard between Dewing Avenue and Oakland Street. As Lafayette became an attractive and more accessible community to live in, Ann Hibbs, an early real estate agent, assisted people in purchasing homes. (Courtesy Contra Costa County Historical Society.)

# Five

# WATER, FIRE, AND OIL

With hot, dry summers, wild land and structure fires were always a threat. The Lafayette Fire District, which had its origins in July 1918, was one of 12 fire companies in Contra Costa County. Louis Starks was the first fire chief in Lafayette; Edward Allen was the assistant chief. About 1920, the city purchased a Model T fire engine, known as Old Betsy. It was outfitted with a 50-gallon soda and acid barrel, which was inverted to fight the fire. It had both an electric starter and a hand crank. Ed Morrison served as the fire chief for 18 years.

In the very early days, water was only available from streams. Elam Brown moved from his first two houses because of lack of water. Eventually wells were dug. Consistent water was an ongoing problem when there were droughts, a concern in the early 1920s. Too much water could be another problem, as flooding caused impassable roads and property and crop damage. Something needed to be done.

The Lafayette Improvement Club (LIC) was responsible for forming a water district that would bring Mokelumne River water to town. Lewis Rodebaugh, Col. M. M. Garrett, M. H. Stanley, and George Meredith worked with the LIC to form the Lafayette County Water District, and Lafayette eventually became part of the East Bay Municipal Utility District (EBMUD). A dam was designed at the west end of town to control flooding and provide water, and construction began in 1927. When it was about 80 percent complete in September 1928, the dam settled over a 10-day period, causing huge cracks to appear. All work stopped for three years as the dam was redesigned with a shorter, wider aspect. Construction was completed in 1933.

Oil had a short history in Lafayette. It was found on the surface at a number of locations, and wells were drilled, but no fields were found to be profitable. Not all the oilmen were honest, and some Lafayette citizens lost money.

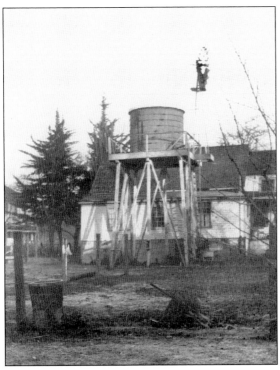

This water tower was located on the Russi property. A water tower was a significant addition to a farm, as it provided a convenient form of water. Water was brought up from a well by the windmill and stored in the tower, which sustained families in times when the wells ran dry. (Courtesy Russi family.)

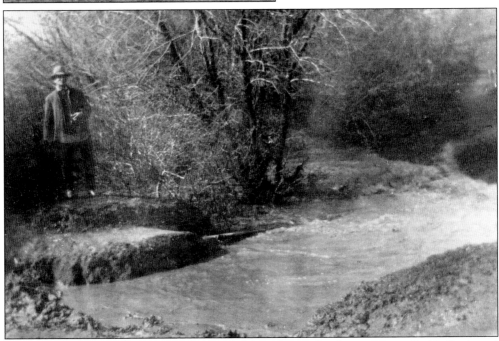

In 1910, Henry Toler Brown looks at the flooding in Lafayette Creek near Mount Diablo Boulevard and Oakland Avenue, the western half of Lafayette Circle. A monstrous flood occurred in January 1862. Warren Brown lost a barn, and a second building tipped over. Cattle died, bridges washed out, and travel was impeded for some time. Much of the state was affected as well. (Courtesy Sybil Brown Wilkinson.)

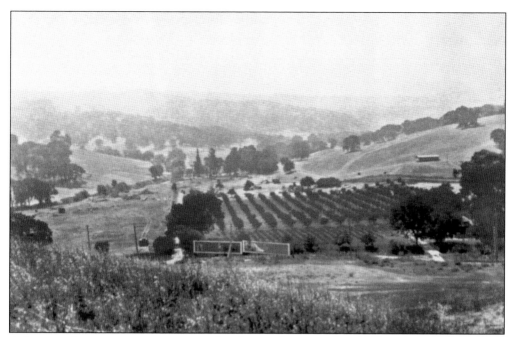

A dam running east to west was proposed at this site facing south in 1927 just beyond the grove of trees at center. Mount Diablo Boulevard is in the foreground with the two billboards facing the street. Pear trees in the fruit orchard still stand today. (Courtesy East Bay Municipal Utility District.)

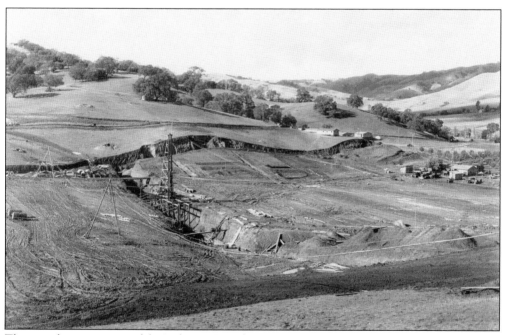

The initial construction of the Lafayette Dam base in 1927 can be seen looking northwest. Eight-foot interlocking steel piles formed a "cut off" to prevent seepage of water under the dam. The construction camp is right of center. Weather delayed some work, and the reservoir began to fill with water, although at a low level. (Courtesy East Bay Municipal Utility District.)

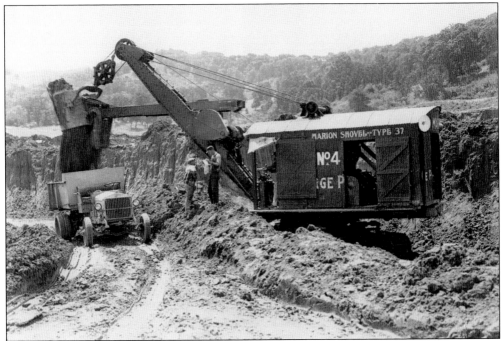

For such a large project, heavy equipment was needed. A steam shovel, a Type 37 Marion, is loading soil from a "borrow pit" during construction of the dam in early 1928. Soil was moved from various areas and trucked to the dam. It was slow, arduous work moving 65,000 cubic yards of dirt. Lou Borghesani, later a Lafayette resident, was a foreman on the construction team. (Courtesy Leo J. Coleman.)

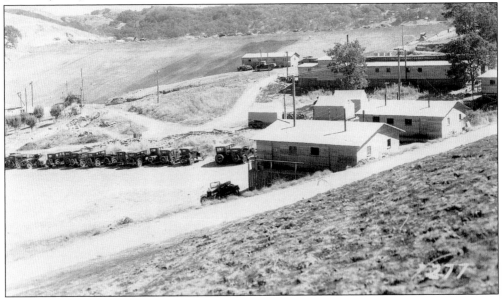

The dam starts to take shape. This view looks at the north or downstream side of the dam, with the construction camp on the right. For such a huge project, men were housed at the camp. Afterwards, the camp was dismantled, and no vestiges of it remain. Mickey Meyers worked on this project before he went into the grocery business. (Courtesy East Bay Municipal Utility District.)

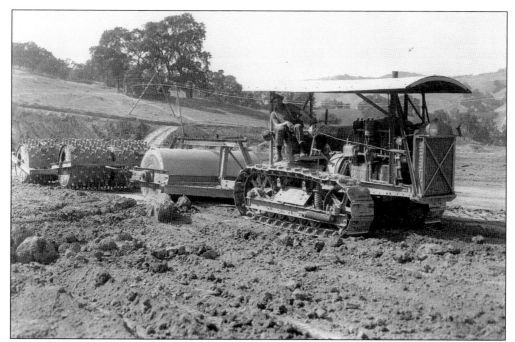

Years of drought in the early 1920s and increased usage of wells from a growing population helped to establish the East Bay Municipal Utility District. A Caterpillar tractor tows a plain roller and sheep's foot roller for compacting the soil down at the base of the dam. (Courtesy East Bay Municipal Utility District.)

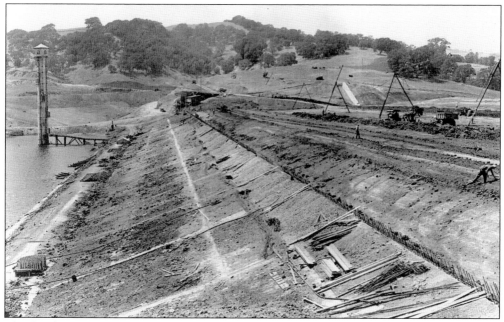

The dam has not yet reached its final height. The apron of the dam was to be concreted to prevent water seepage. The water tower was equipped with valves and pipes to send water to the filter station across from the bottom of the dam. At dam completion, the tower would be barely above the water. The water seen here is rainwater. (Courtesy East Bay Municipal Utility District.)

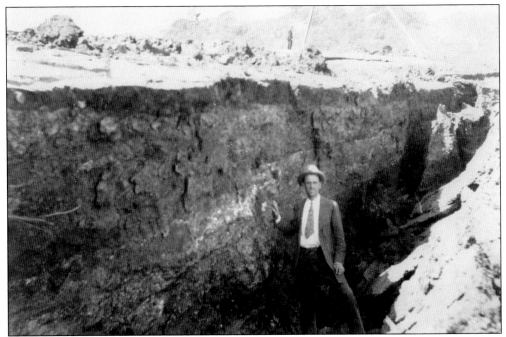

The dam settled in September 1928 over a 10-day period. Leo J. Coleman, engineer for EBMUD, stands in the chasm created by the collapse. The night of the first cracks, Coleman had walked across the dam in darkness, which caused him to tumble down the face of the dam. He was groggy for awhile, and when he felt around, he realized that the concrete apron was four feet up in the air! (Courtesy Leo J. Coleman.)

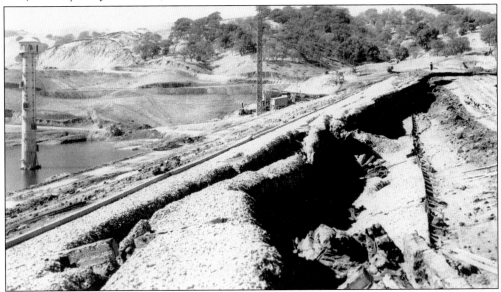

A year before the dam collapse, the St. Francis Dam in Los Angeles County failed, and 400 people died. Residents of Lafayette remembered and were worried. If the dam had been filled, Lafayette and Walnut Creek would have been flooded. Work on the dam stopped for three years after it settled. It was finally completed in 1933, six years after the beginning of construction. (Courtesy East Bay Municipal Utility District.)

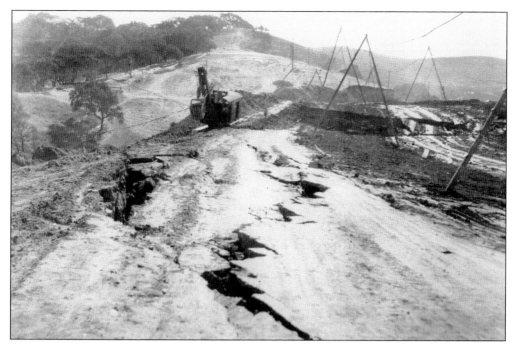

Cleanup work is starting. The investigation into the collapse found that the soils were the wrong type to support so much weight. The redesign called for a shorter, wider dam and only about a third of the water storage. The water is now a backup supply only. In 1966, the reservoir was opened as a recreation area, something innovative at the time. (Courtesy Leo J. Coleman.)

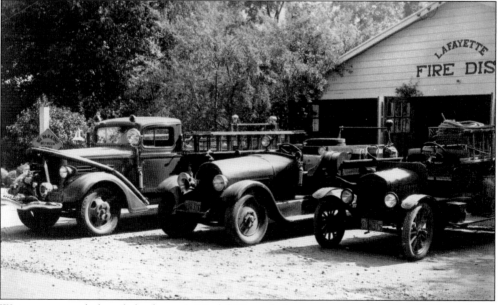

Water was needed to fight fires. A Model T truck frame was purchased c. 1920, outfitted as a fire truck, and named Old Betsy, serving Lafayette during the 1920s and 1930s. It was sold and stored in Earl Sankos's barn in Pleasant Hill. The Lafayette Fire District had three trucks in the 1930s at the firehouse on Moraga Road. Old Betsy is pictured at right. (Courtesy Lafayette Fire Department.)

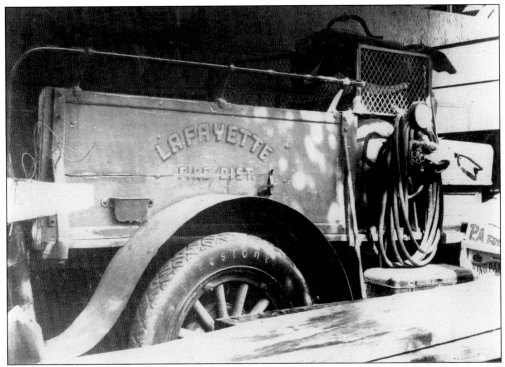

Old Betsy had an electric starter and a hand crank, as well as a $CO_2$ canister to fight fires. In June 1977, Lafayette citizens repurchased Betsy, and Hubbard Anderson, Mike Roberts, George Wasson, and the Lafayette Jaycees faithfully restored the truck. For years, the old fire truck was a mainstay in parades, giving rides to children after the parade. (Courtesy *Contra Costa Sun*.)

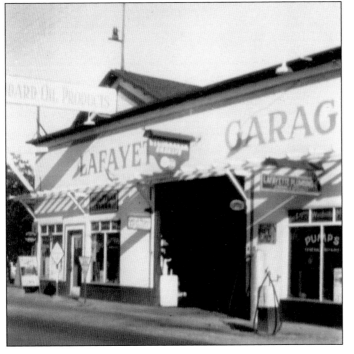

In 1928, Chief Ed Morrison bought this building, located on the southwest corner of Dewing Avenue and Tunnel Road (renamed Mount Diablo Boulevard), from Harry Bower. Old Betsy was stored there while Chief Morrison owned the garage. The truck will be proudly showcased in the Lafayette Library and Learning Center, to be opened in 2009. (Courtesy M. Symmons.)

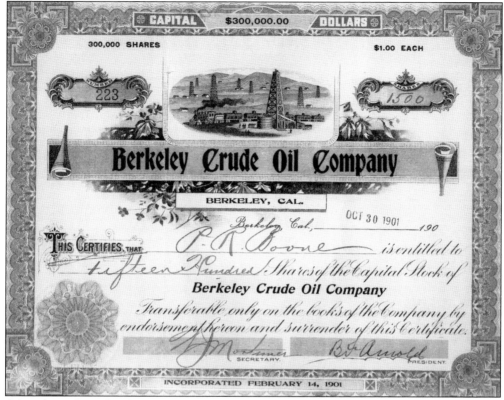

Oil on the surface of land was discovered in Lafayette by a realtor in Upper Happy Valley. Speculators formed companies, sold stock, and drilled. A stock certificate for the Berkeley Crude Oil Company was made out to P. R. Boone for 1,500 shares at $1 each. (Courtesy Louis L. Stein Jr.)

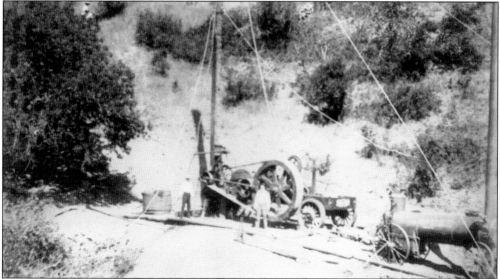

A rig was erected on the Edward Flood ranch in Upper Happy Valley near Peardale Drive, where oil was discovered in 1901. If large oil fields had been found, the rural aspect of Lafayette would have been changed to a more industrial one. (Courtesy Flood family.)

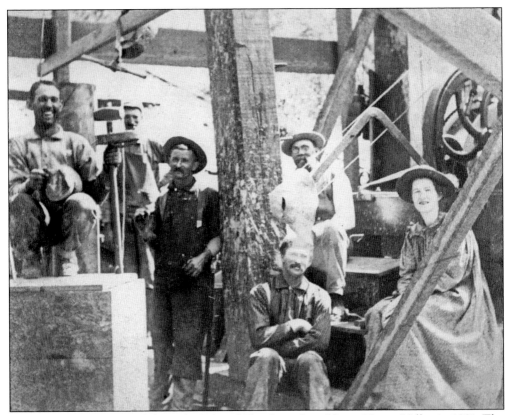

Four workmen are to the left on the Edward Flood ranch in Upper Happy Valley in 1901. The man seated without the hat is Alexander Flood (who was a redheaded Irishman), and the woman is Evelyne Flood Baker, his sister. (Courtesy Flood family.)

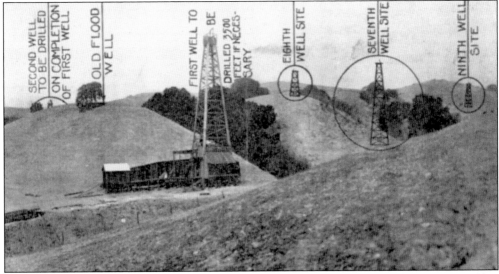

Extensive drilling occurred over a period of some years in order to locate oil in Happy Valley. There were five more wells in addition to those pictured here. Dreams of black gold were never realized, though. (Courtesy Louis L. Stein Jr.)

# Six

# ROADS, TUNNELS, AND RAILS

Lafayette was at the crossroads of four towns: Oakland, Martinez, Walnut Creek, and Canyon/ Moraga. Lafayette residents traveled to Oakland for its many stores and amenities, for medical care, and to sell hay, fruits, and vegetables. The first roads to Oakland went over the top of the hills, a 1,000-foot climb. The Kennedy Tunnel was opened in 1903, 320 feet below the top of Summit Road.

Lafayette was situated between Canyon, Moraga, and Martinez. Near Canyon were the redwoods where Elam Brown worked before he settled in Lafayette. The redwood timber was hauled to Martinez and shipped from the shipyards. Martinez was the county seat, where lawsuits, jury duty, and voting took place. With its hotels and saloons, Lafayette was an early way station for teamsters (wagon drivers).

The Pony Express, a fast mail service, crossed the continent from the Missouri River to the Pacific coast from April 1860 to November 1861. In 1860, the Pony Express stopped three times in Lafayette on the way from Sacramento to San Francisco; it stopped 17 times in 1861.

Roads in the early days were dusty in summer and full of ruts—sometimes impassable—in winter. All year long there were chuck holes. The county paved Tunnel Road from the tunnel to Walnut Creek in 1916 at the urging of the LIC. Slowly other roads were rocked and paved.

In 1913, the Oakland, Antioch and Eastern Railway (O, A&E) started service through Lafayette. The name was changed to the Sacramento Northern Railroad in 1928. The electric train was used daily by commuters and students. Riders could start in San Francisco, take the ferry, and ride all the way to Sacramento.

In 1937, a new tunnel, the Broadway Low Level Tunnel, opened 310 feet below the Kennedy Tunnel. A third bore opened in 1964. Today all three are collectively called the Caldecott Tunnel.

Tunnel Road eventually became Mount Diablo Boulevard. The ease of driving through the tunnel caused people to stop taking trains, and passenger rail service ended in 1941. The railroad right-of-way through Lafayette and Moraga became a walking trail in the 1970s.

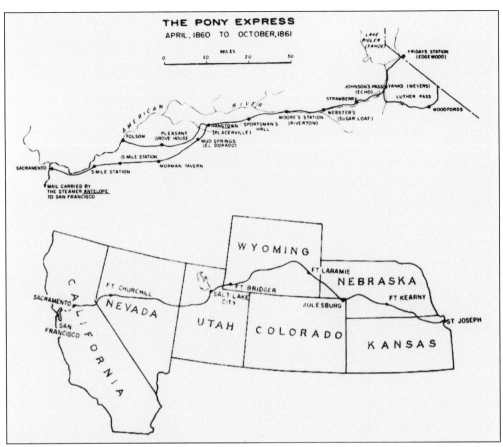

DEDICATED APRIL 23. 1998
## LAFAYETTE HOUSE
ADDED STATION
APR. 23. 1860 - SEP. 8. 1861

The Pony Express began carrying mail in 1860 between St. Joseph, Missouri, and San Francisco. Riders galloped about 10 miles between each station, changed horses, and transferred the *mochila*, a special leather saddlebag for mail. Coming west, the last stretch was a boat ride from Sacramento to San Francisco. However, riders sometimes missed the boat and had to ride overland from Sacramento to Oakland, where they took a ferry to San Francisco. Lafayette House, run by N. P. Lake, was the way station on the corner of Mount Diablo Boulevard and Moraga Road, where a monument stands today. The rider came in from Martinez, changed horses, and galloped on. There were 20 overland routes in 1860–1861, only westbound. The completion of the nationwide telegraph network in 1861 doomed the Pony Express. (Above courtesy Tice Valley Rossmoor Historical Society.)

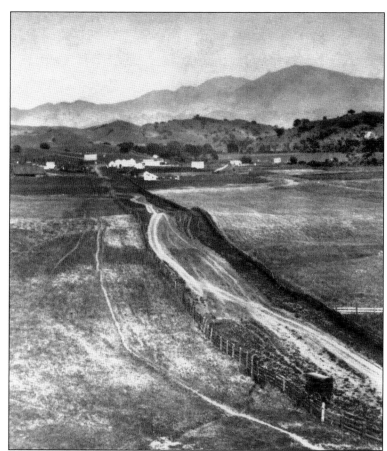

This is the county road from Bryant (Orinda) looking east towards Lafayette with Mount Diablo in the background; the original path got sidetracked due to deep ruts. This 1869 photograph may be the oldest known image of Lafayette. For a short while, 10 years earlier, J. W. Morris ran a two-horse stagecoach from Oakland through Lafayette to Martinez, weather permitting. Note the photographer's covered wagon sitting by the fence; he developed his tintype photographs inside. (Courtesy Louis L. Stein Jr.)

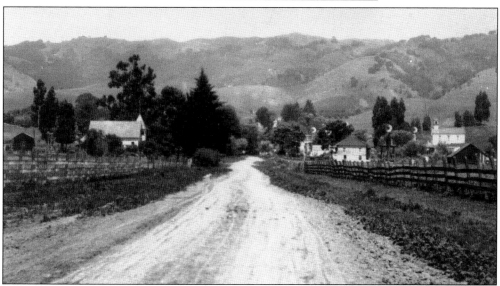

This is Moraga Road in 1915 looking north toward Mount Diablo Boulevard. On the left are the third schoolhouse and the back of Elam Brown's home and barn. On the right are the Allen house and the Methodist Church on the hill. (Courtesy Louis L. Stein Jr.)

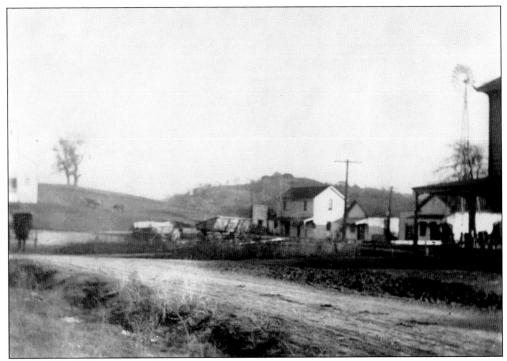

Tunnel Road went past the plaza in the late 1880s. Other buildings are, from left to right, Good Templar Hall, the Wayside Inn (built in 1894), the Geils Building (built in 1880), the Pioneer Store (built in 1864), a windmill, and the porch of the Hastings Hotel in the right foreground. Alice McNeil Russi noted, "It used to be so quiet. You could hear the ring of the blacksmith's hammer and people's voices from far away." (Courtesy Lillian Armanino.)

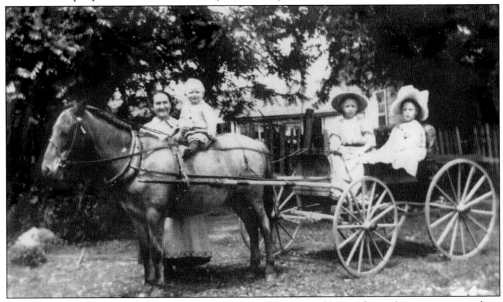

Before the age of the automobile, many Lafayette families owned horse-drawn buggies to carry their families. In this 1915 photograph, Kenneth Brown is sitting on the horse next to his grandmother Annie Brown. In the buggy are Helen ? and Mildred Root. (Courtesy Sybil Brown Wilkinson.)

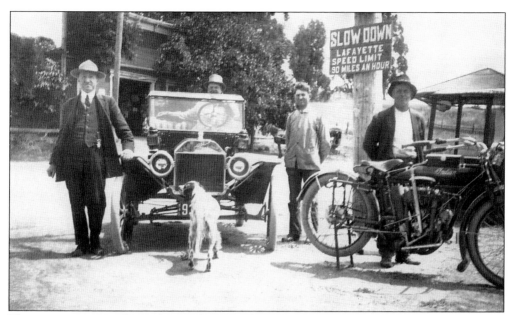

This street scene is in front of Peter Thomson's blacksmith shop in the early 1900s. The sign says, "SLOW DOWN, Lafayette Speed Limit 90 miles an hour." Rita Santos, in her oral history, remembered that when the first automobiles came through town, the children would hear them coming, and the teacher would let them out of school to see the cars go by. (Courtesy McNeil family.)

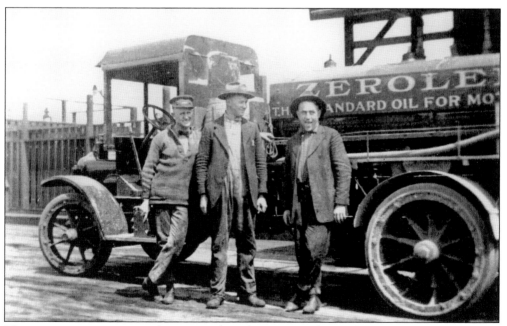

Three men, one appearing to be an attendant, lean against the Zerolene truck. The lettering on the truck says, "Standard Oil for Motor Cars." Louis L. Stein Jr. remembers his father having a 1916 Dodge. With the roads so bad, they always carried an extra axle in the back, and if it broke, the screws could be removed and the axle replaced. (Courtesy McNeil family.)

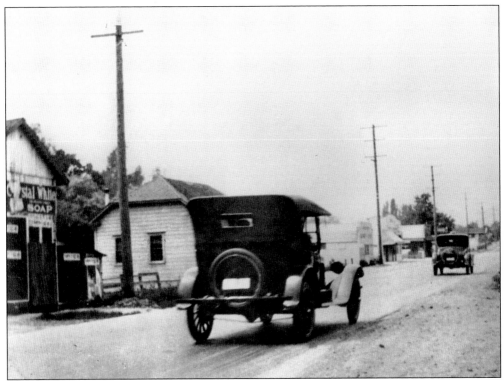

Through the efforts of the Lafayette Improvement Club, Tunnel Road was paved in 1916. Eighteen feet wide and 5 inches deep, the new roadway ran from the tunnel through Bryant (Orinda) and Lafayette to Walnut Creek. It was such a feat that there was a *chamarita* (festival) in honor of the occasion. This photograph shows Mount Diablo Boulevard 10 years later, in 1926. (Courtesy *Oakland Tribune*.)

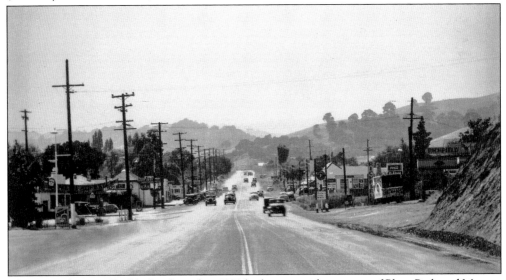

This view of Mount Diablo Boulevard in 1930 looks west with a corner of Plaza Park and Moraga Road on the left. The road was not straight, and there still weren't any curbs or formal sidewalks in town. (Courtesy Louis L. Stein Jr.)

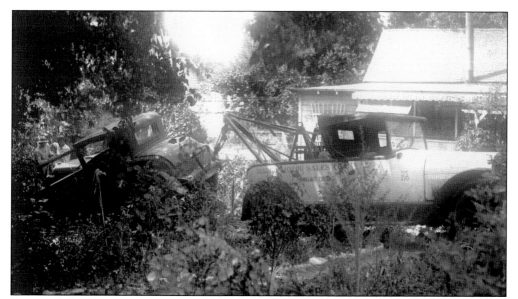

Even though there were not many cars on the roads at the time, accidents still happened. The automobiles of Professor Rice of UC Berkeley and Jack O'Donnell of Moraga collided near the Wayside Inn in 1934. One car fell into Pat Medau's fish pond. Doctor Beebe treated both drivers for minor injuries. A wrecker from Diablo Motor Sales of Walnut Creek towed the vehicles. (Courtesy Shirley Medau.)

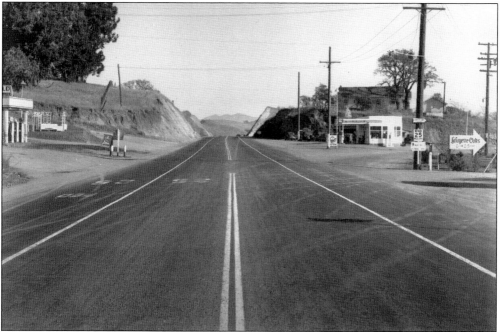

Looking east on Mount Diablo Boulevard in 1937, Plaza Park is visible on the right. The "Lafayette Oaks" advertisement is for properties on Hawthorne Drive sold by Sweet Real Estate. King's Restaurant and the 76 gas station are on the right. Grant Miller's home on the hill was located where the Good Templar's Hall stood in the 1800s. The hill was leveled soon after. (Courtesy Louis L. Stein Jr.)

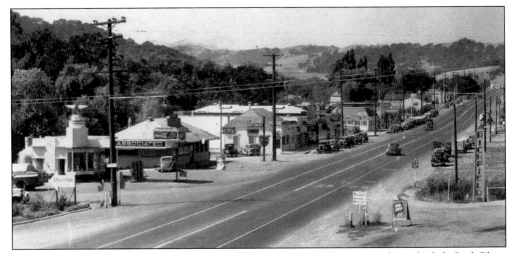

This is Mount Diablo Boulevard in the late 1930s; Moraga Road comes in from the left. Park Plaza is on the left with the Flying A (Associated) gas station, Bill's restaurant, a real estate office, the Plaza Creamery, Lou's Bar, and Meyers's Groceteria. (Courtesy Russi family.)

Here are graphic directions to Dr. Alvin Powell's home on Tanglewood Road off Moraga Road in 1937. Starting from the west, take Highway 24 to the PG&E substation, take a right and go through the bores of the new Broadway Low Level Tunnel (Caldecott Tunnel), take a left and go straight until the Associated Gas Station, and take a right and continue past the school. Alvin and Josephine Powell are shown with their children David and Mary. (Courtesy Powell family.)

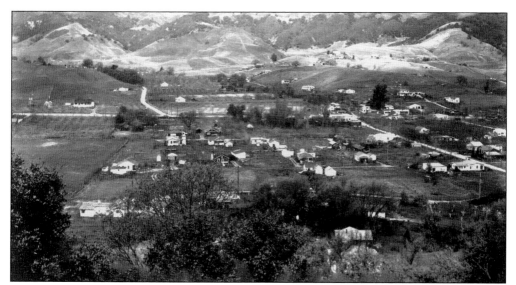

Andrew Young notes that the Lafayette Improvement Club had a great influence on the city. One of their subtle but important successes was to have zoned land use. There was a commercial business district, some high-density housing, and several semirural areas. In this 1938 view, farmland is giving way to houses. (Courtesy Clyde Sunderland.)

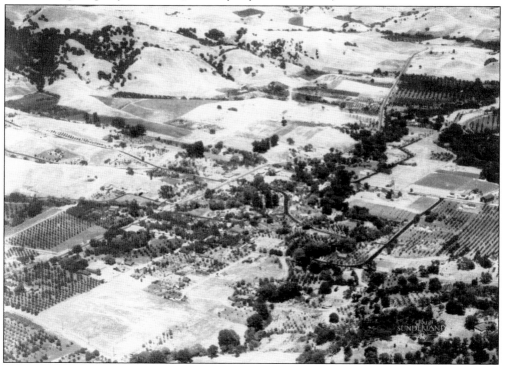

This 1936 aerial view of Lafayette is looking northeast. Town Hall and the Lafayette School are seen in the center on the right edge of the photograph. Mount Diablo Boulevard is diagonal from lower left to upper right. Many of Lafayette's streets are named after early residents: Brown Avenue, Hough Street, Dewing Avenue, Hamlin Road, Oliver Road, Burton Drive, Bickerstaff Street, and Hunsaker Canyon Road. (Courtesy Clyde Sunderland.)

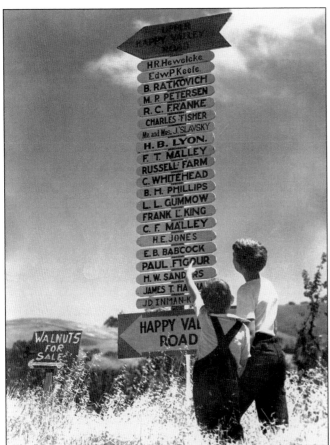

Alan Stanley, age 4, and Richard Stanley, age 11, stand by a sign showing the names of Upper Happy Valley residents. Another arrow points in the direction of Happy Valley Road. As this was an agricultural area, many farm families sold fruits, vegetables, and other crops they harvested to local residents. (Courtesy Stanley family.)

This view is looking east down Mount Diablo Boulevard in 1940. The entrance to the cemetery is on the right, and a service station is farther down the road. At this time, most of the homes and businesses were still closer to the downtown area. (Courtesy Louis L. Stein Jr.)

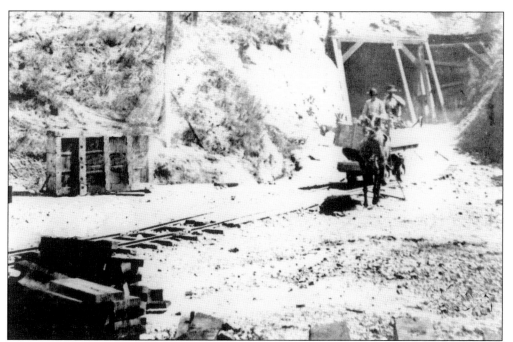

Residents of Contra Costa County needed a better means of travel to get to Oakland, and as early as 1861 a tunnel was proposed. After one false start, the tunnel was finally completed at the end of 1903. Although cars could pass in either direction, one hay wagon would take up the entire width of the tunnel. In this photograph, the Kennedy Tunnel is under construction. (Courtesy Contra Costa County Historical Society.)

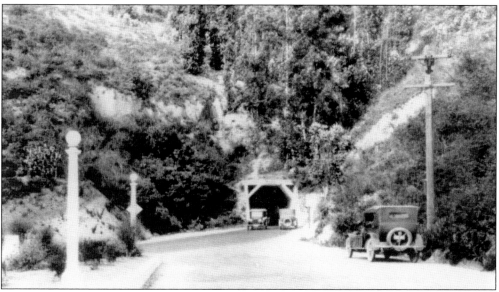

This is the west entrance to the Kennedy Tunnel (Old Tunnel), 320 feet below the summit. Travel could be hazardous. Occasionally drivers were halted and robbed. There was no lighting in the tunnel until 1918, although sometimes torches were lit at one end so they could be seen at the other end. Others guided themselves through by feeling the wall with a buggy whip. (Courtesy Contra Costa County Historical Society.)

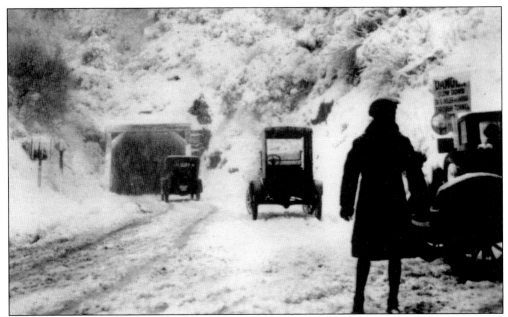

The old Kennedy Tunnel dripped constantly, making the roadbed slippery. Other problems developed when slides across the roadway approaching the tunnel closed it for extended periods in 1912 and 1915. The increase in traffic and the long climb caused the need for a new tunnel. This extremely rare occasion of snow occurred in 1922, making the hill climb treacherous. (Courtesy Contra Costa County Historical Society.)

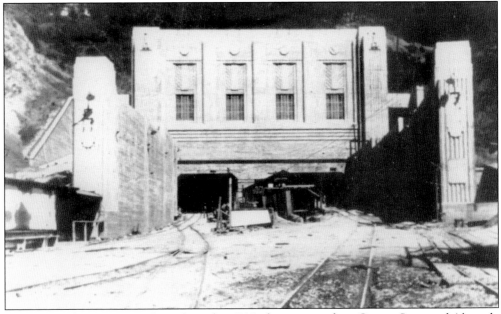

The Joint Highway District 13 was formed in 1928 of supervisors from Contra Costa and Alameda Counties to build a new tunnel. After property acquisition and design, the tunnel was built in two years. It is 310 feet below the old Kennedy Tunnel and 630 feet below the summit. The two bores meet at the portal at each end but are actually 150 feet apart in the center. (Courtesy Contra Costa County Historical Society.)

The composite photograph above shows the elaborate movable platform for tunnel construction. Its purpose was to facilitate building and reinforce the forms used to hold the wet concrete in place while it sets and dries. At upper left, the vertical beams held the inner form in place. At upper right, the planks of the outer form held back the soil. In the distant tunnel, the completed concrete walls are pictured with the upper and lower ventilation openings. With the rails removed, the lower photograph shows the portal nearing completion with its art deco embellishments. The bores are curved, not straight, and are higher in elevation on the east end. Another two-lane bore was added in 1964. The direction of the center bore is switched depending on commuter traffic. (Both courtesy Contra Costa County Historical Society.)

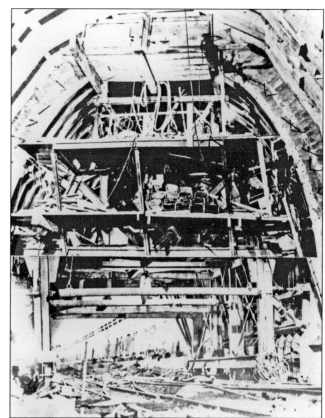

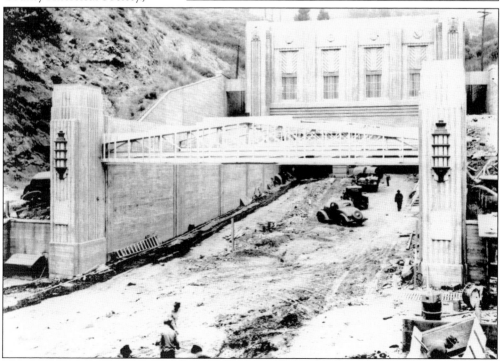

A luncheon preceding the Broadway Low Level Tunnel ground breaking in 1934 was held at the Claremont Hotel. At far left is Miss Berkeley; in the center is Earl Lee Kelley, director of Public Works; and at far right is Miss Lafayette, Katherine Schutt. (Courtesy Katherine Schutt.)

The first cars are going through the East Portal on the opening day of the Broadway Low Level Tunnel on December 5, 1937. The tunnel was later named after Thomas Caldecott, the president of the board of directors of the Joint Highway District. (Courtesy Lafayette Historical Society.)

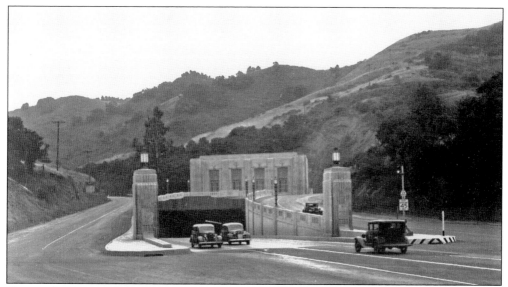

Here is the East Portal of the tunnel in 1937. After the construction of the new tunnel, the Kennedy Tunnel was boarded up. The new tunnel made it more convenient for people to drive to Oakland or to San Francisco over the newly opened Bay Bridge. (Courtesy Edith Lynn.)

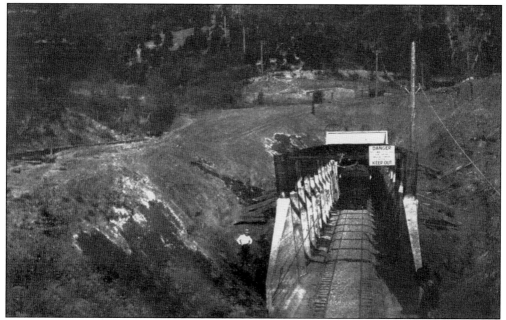

Just as cars needed a shortcut from the summit traverse, trains did too. The Oakland, Antioch and Eastern Railroad (O, A&E) was created in 1913 to carry freight and passengers. The train tunnel was separate and south of the car tunnel. This photograph shows the entrance to the 3,200-foot tunnel from the Oakland (or west) side on its way to Canyon, Moraga, and Lafayette. (Courtesy Lewis Rodebaugh.)

In 1928, the O, A&E railroad became the Sacramento Northern. In the early days, the trains were single cars, and there were special observation cars on express trains. The electric railroad, with a 600-volt system, began service through Lafayette in 1913. Although it looked lonely going through Lafayette, it was actually quite scenic, especially when climbing the hills to the train tunnel. (Courtesy Lewis Rodebaugh.)

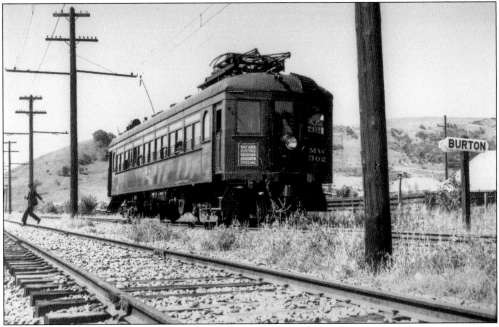

Passengers commuting to San Francisco went through the train tunnel, over the Key System in Oakland, and transferred to a ferry for the city. On the trip to Sacramento, there was a ferry called the *Ramon* from Suisun Bay to Chipps Island, Sacramento, and Chico. At first, Lafayette and Burton were the only two stops. Burton Station, with its long sidetrack, is pictured on the last day of passenger service in 1941. (Courtesy Warren Miller.)

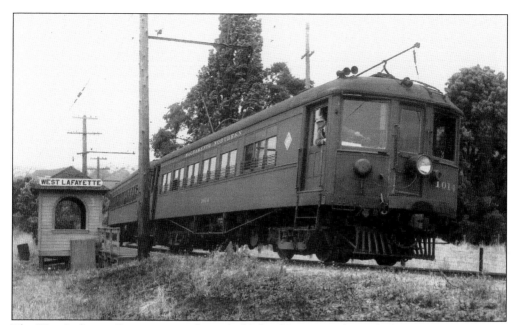

The West Lafayette Station was at the end of School Street. In the early days of service a special 3:00 a.m. train waited to take home Town Hall partiers who had come from Walnut Creek or Oakland to dance the night away. Special trains were also in service to take picnickers to Redwood Canyon during the summer months, on weekends, and on holidays. (Courtesy Warren Miller.)

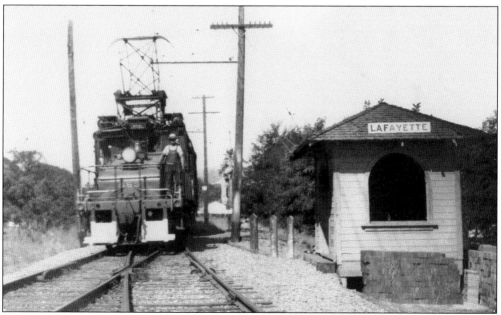

This is a steeple cab freight train, Engine No. 653, at the Lafayette station on Moraga Boulevard, looking west. Carrie Van Meter would give children rides in her old car to this station to pick up the mail. At harvest time, there were extra trains for produce. Over the years, the Lafayette stops were Burton, Glenside, West Lafayette, Lafayette, and Raliez; some were flag stops. (Courtesy Gumz family.)

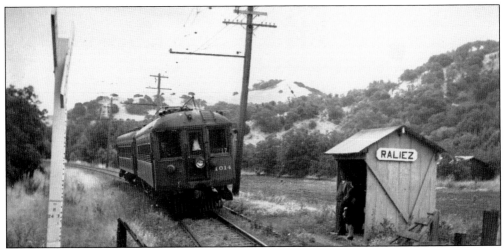

A passenger waits at the Raliez station, which was near Olympic Boulevard and Reliez Station Road. The spelling was changed in later years. A following stop, Saranap, was a transfer station to Alamo, Danville, and Diablo Station. Used by commuters for holiday travel and by students from Lafayette attending Mount Diablo Union High School in Concord, the railroad prospered. (Courtesy Louis L. Stein Jr.)

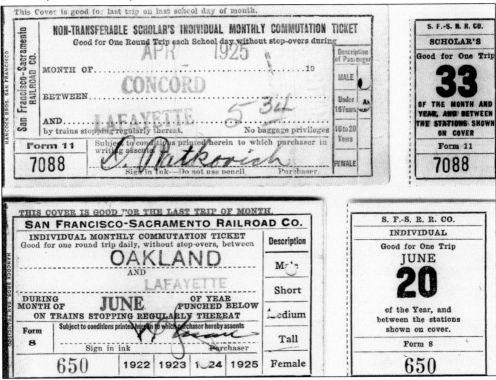

A monthly book of discounted tickets was $5.75 for service to Oakland and $7 to San Francisco. With the opening of the Caldecott Tunnel in 1937, commuters drove their cars instead of riding the rails. The train cancelled passenger service to Lafayette in 1941 and freight service in 1957. Through the cooperation of many agencies, the train right-of-way became a hiking trail in the 1970s. (Courtesy D. Ratkovich, V. D. Stuart.)

*Seven*

# HOMES

One of the earliest homes in Lafayette was built in February 1848 in Happy Valley by pioneer Elam Brown. Upon arriving at his newly purchased Rancho Acalanes, he needed to build a structure to shelter his family during the winter months. The house was probably built of canvas and wood with earthen floors. When Brown decided to relocate his gristmill closer to the downtown area, it made sense to relocate his home too. His wife, Margaret, was unwilling to move unless the new house would include wooden floors, probably having tired of dirt and mud underfoot. This was the first of several homes the Browns built in the downtown area.

As the settlement began to grow, many of the early settlers built homes for themselves in the downtown area. Many merchants and store owners lived next to or above their businesses. As children grew and married, many stayed in Lafayette and ran family businesses. Some farmers built homes on their land near the town, and some lived in town and farmed their outlying land.

With the arrival of plumbing and electricity, daily life became easier for the residents, especially the women. With more free time, they could participate in civic and community activities. Automobiles, paved roads, and the construction of the Kennedy and Caldecott Tunnels opened up the suburbs for further growth so people could live in the country and work in nearby cities. Farmlands were sold to developers, and more homes were built. Lafayette was a comfortable place to live, close to Oakland and San Francisco. The change from a farming community to a residential community was under way.

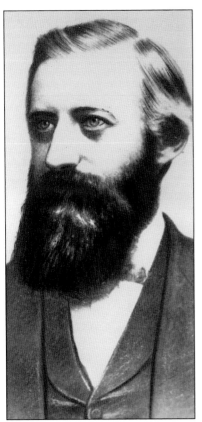

Horace Carpentier was a land speculator who came to California in 1849. At one time, he claimed the Moraga Rancho as payment for unpaid legal services and the Peralta family land, which later became Oakland. His methods of acquiring property ranged from outright squatting to harassment of the Mexican grantees. He built this house in the Lafayette area c. 1865, one of his extensive holdings throughout California and the United States. The Arthur J. Burton family lived in the house from 1886 to 1925, and the property was known as the Burton ranch, from which the valley and school take their names. (Left courtesy Oakland Public Library; below courtesy Katherine McVean.)

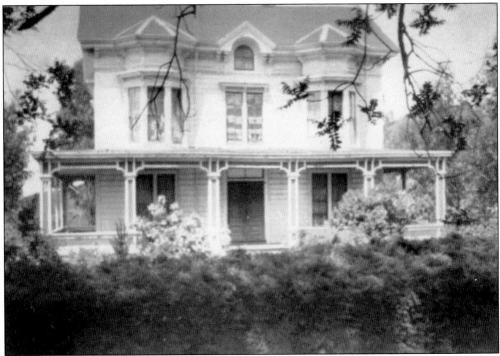

Samuel Hodges came overland to California from Wisconsin in 1850. He first became a miner, but having little success, he planned to return to the East. Coming down to the California coast, however, he was so pleased with the county that he purchased 275 acres of good farming and pasture land on the eastern side of Reliez Station Road. He grew wheat, barley, and fruit trees. (Courtesy Hodges family.)

This lithograph, from a book of illustrations of Contra Costa County published by Smith and Elliott, describes Samuel Hodges's home in what was called Taylor Valley as "a two story building at a suitable distance from the public road, among some fine large trees that line the bank of the creek. The farm is midway between Lafayette and Walnut Creek on a beautiful stream called 'Raleez' Creek, the banks of which are lined with oak and laurel." (Courtesy Contra Costa County Historical Society.)

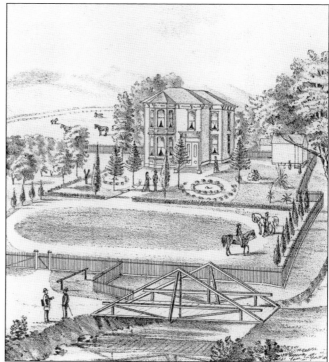

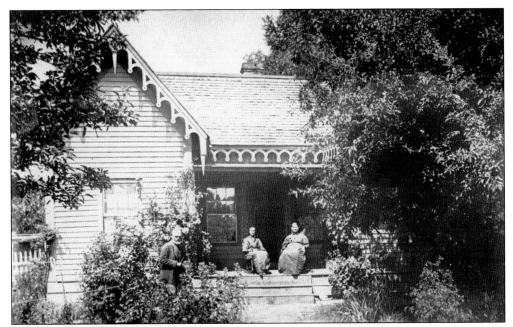

This home, owned by Warren Brown, was located at the present address of 971 Moraga Road, not far from Elam Brown's home on Hough Street (now Lafayette Circle). On the porch c. 1893 are, from left to right, Laura Brown (wife of Warren) and her mother Lois Hastings. Standing is George Ware (the hired man). (Courtesy Sybil Brown Wilkinson.)

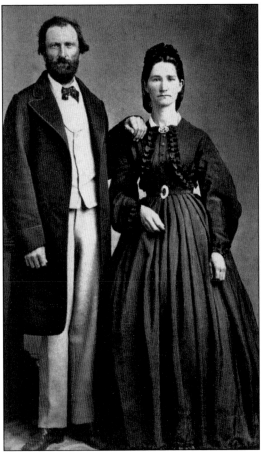

The photograph is of Warren and Laura Hastings Brown, who were married in 1854. Laura and Warren, the son of Elam Brown, had no children of their own but her cousin Henry Hastings lived with them. Warren Brown served the county as surveyor and sheriff and was an assemblyman in the state assembly. In the last years of his life, he farmed his 550-acre ranch in Lafayette. (Courtesy Sybil Brown Wilkinson.)

The home of Robert and Gertrude McNeil, pictured here in 1902, was in Happy Valley. When he purchased the Pioneer Store, it was the only one between Walnut Creek and Oakland. Robert was the son of William and Jane Allen McNeil, and Gertrude was the daughter of Robert Thomson, brother of Peter Thomson. (Courtesy R. E. Amiden.)

This photograph of Robert Elam McNeil and Gertrude Thomson McNeil was taken in 1915. Married in 1890 when they were both 17, they were the owners of the Pioneer Store from 1902 to 1935, and both took an active part in the development of the community. The first meeting of the Lafayette Improvement Club was held at the Pioneer Store. Gertrude was active in the upkeep of the Lafayette Cemetery. (Courtesy Alice McNeil Russi.)

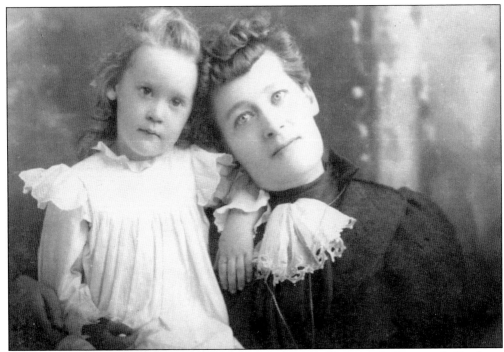

Carrie Hough Van Meter and her daughter Pearl are shown in this c. 1900 photograph. Pearl was born in 1898 and died of appendicitis in 1922. Carrie lived until 1955 but was reclusive in her later years, never recovering from the loss of her daughter. (Courtesy Marjorie Gray Holden.)

Carrie Van Meter's father, Orlando Hough, around 1910, built her home, located on Mount Diablo Boulevard and Moraga Road. Carrie Van Meter was the postmistress from 1904 to 1927 and librarian in Lafayette from 1915 to 1947. The horse and buggy belonged to Georgia Bronson, who carried the mail from Walnut Creek to Lafayette and also brought sacks of bread for the Pioneer Store. (Courtesy Katherine McVean.)

Henry Toler Brown built this home on Moraga Road. Walnut trees from the yard were cut down to make gun stocks for World War I rifles. This 1915 photograph shows, from left to right, Edna Root Brown (mother of Kenneth) and little boy Kenneth Brown; (second row) Millie Stevens and Annie Brown; (third row) Sybil Brown in middy blouse. (Courtesy Sybil Brown Wilkinson.)

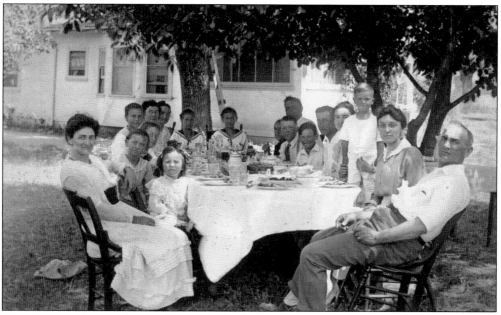

This photograph was taken at the annual birthday picnic party for Henry Toler Brown on July 4, 1916, at his home on Moraga Road. Pictured are, from left to right, Stella, Ramona, Gynth, and Armina Mullikin; Leela Stevens; Ruth Stevens; Annie Brown (Henry's wife); the Stevens twins, Anne and Dorna; Sybil's grandmother Margaret Willebrands; Winfred Stevens; Delmar Mullikin; Kenneth Brown (boy); Guy Hamilton (Sybil's husband); Sybil Brown Hamilton; Warren Brown; Edna Root Brown (Kenneth and Warren's mother); and Henry Toler Brown. (Courtesy Dr. L. Stevens Craig.)

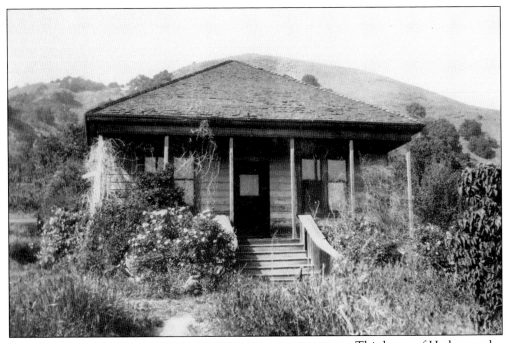

This home of Herbert and Estella Brown Mullikin was built in 1900 in Happy Valley across from Happy Valley Elementary School and not far from Elam Brown's original home. (Courtesy Sybil Brown Wilkinson.)

Herbert and Estella Brown Mullikin are pictured on their wedding day in 1902. Estella (or Stella) was the daughter of Henry Toler Brown and the sister of Sybil Brown. She died in November 1969. (Courtesy Sybil Brown Wilkinson.)

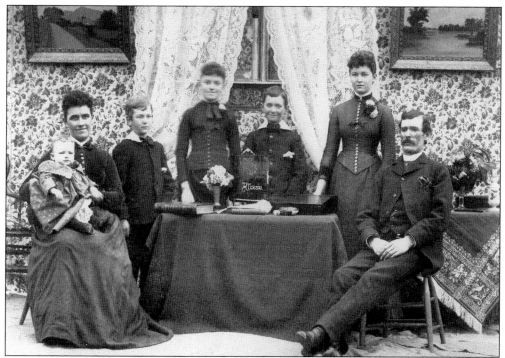

The Robert Thomson family is pictured about 1889. From left to right are Charlotte Maloney Thomson, Agnes (on her mother's lap), Frederick, Harriet, Edgar, Gertrude, and Robert. Gertrude was Alice McNeil Russi's mother. Posed photographs such as these were common, as traveling photographers would come to town to take family portraits. (Courtesy Alice McNeil Russi.)

Robert Thomson's home (c. 1920) was at the corner of Oakland Avenue and Mount Diablo Boulevard. This photograph shows the house after the big snow of 1922. (Courtesy Alice McNeil Russi.)

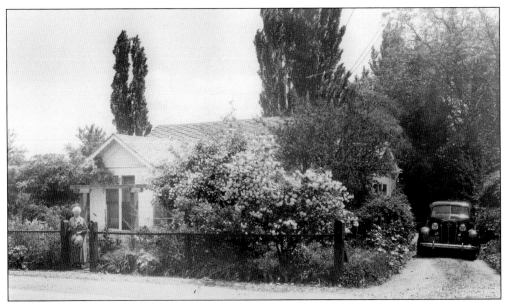

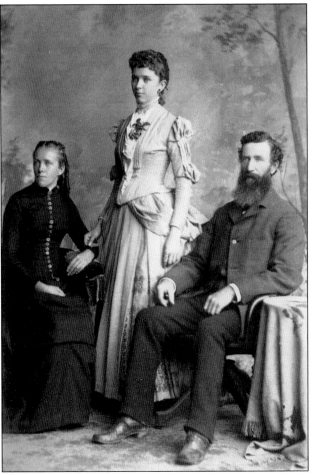

This house was built by James Bickerstaff in 1879 on an acre of land purchased from Elam Brown. James hired Andrew Allen to build the house, and Josiah Allen to add two front rooms in 1892. They were both sons of Margaret Allen Brown. James's daughter Margaret is shown at the gate around 1930. She helped plant the redwood trees in the family garden behind the house. (Courtesy Margaret Bickerstaff Rosenberg.)

Margaret Bickerstaff and her parents, James and Delilah, pose for this 1888 portrait. The family came to Lafayette by train in 1877, when Margaret was seven years old. The family moved to San Jose in 1889 so Margaret could earn her teaching certificate at San Jose State Normal School. Three years later, the family returned to Lafayette, and Margaret received her first teaching assignment at the Moraga School. (Courtesy Margaret Bickerstaff Rosenberg.)

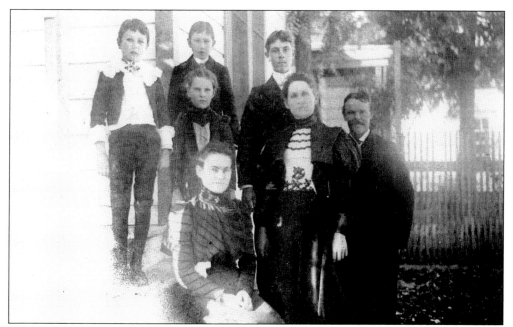

The Albert Hodges family is pictured on Thanksgiving Day in 1900. From left to right are (first row) Emma Donner (Hattie's sister), who taught at the Lafayette School with Margaret Bickerstaff; (second row) Harold, Frank, and Sumner; (third row) Alberta, Hattie, and Alberta. Emma taught 40 pupils and earned $60 a month. She paid $20 a month to the Hodges for room and board. (Courtesy Sumner Hodges.)

Albert Hodges's home was located near Pleasant Hill Road by Reliez Creek. The house had no studs and a 2-by-10-foot board was nailed the full length of the house. A steep stairway was in the center of the one-and-a-half-story house. Downstairs were a kitchen and living room, and upstairs two bedrooms. The redwood house had a single wall covered inside with cotton cloth and wallpaper. (Courtesy Sumner Hodges.)

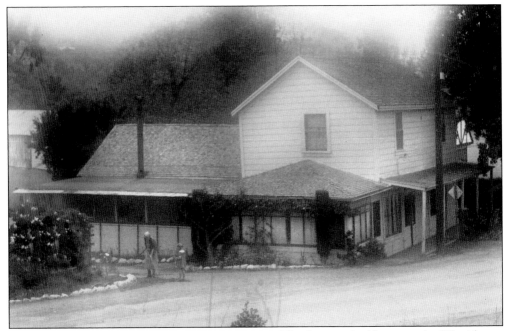

This historic building was the Wayside Inn, constructed in the late 1840s by the Medau family. Lizzie Medau is pictured here with her granddaughter Patsy Reading. The family lived in the building at the back of the store. (Courtesy Medau family.)

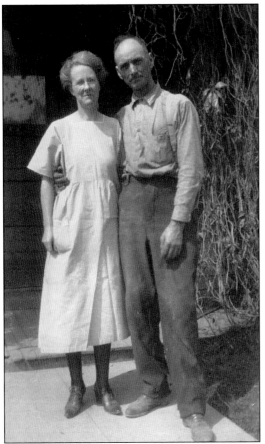

A c. 1920 photograph of Pat and Lizzie Flood Medau was taken in the garden of their home, the Wayside Inn. Pat ran the store and meat market. Lizzie had several pets, one of the most exotic being Eddie the monkey, who had the run of the inn. (Courtesy Shirley Medau.)

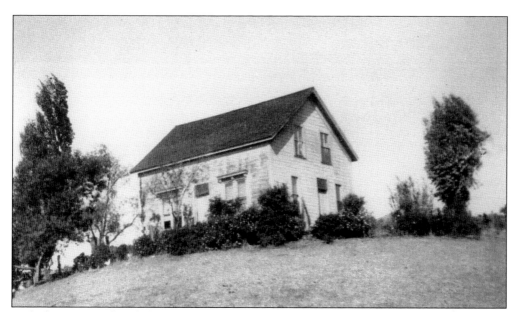

In the late 1800s, Edward Flood purchased several hundred acres for his ranch in the Upper Happy Valley area near Peardale Drive. It was on this ranch that one of the oil wells was drilled during the oil "rush." The house burned down in 1910. (Courtesy Louis L. Stein Jr.)

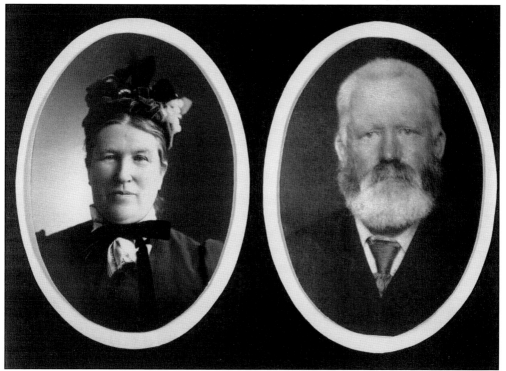

Edward Flood, a carpenter, was born in Dublin County, Ireland. He married Anne Hopkins in 1868 in County Carlow, and they had eight children. In the 1880s, they emigrated from Ireland. They lived in Lafayette and owned the Wayside Inn. One of their children was Lizzie, who married Pat Medau. (Courtesy Genevieve Gallagher.)

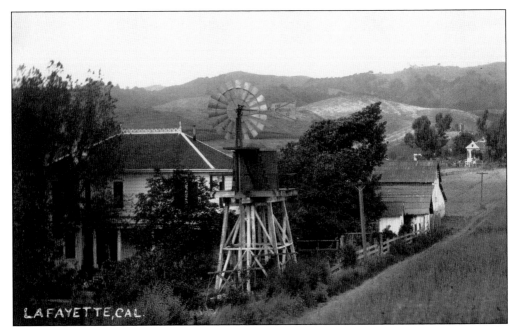

Peter Thomson built this home about 1870. It was located behind the blacksmith shop near the west end of the Plaza Shopping Center. After his death, it was the home of his son William. Early business owners often lived near or above their places of business. (Courtesy Orville Jones.)

Nat Martino bought this farmhouse in 1919 when he purchased 90 acres of land for his ranch in Spring Hill from Fred Easton, who built the house in 1876. Martino was an immigrant from Italy who grew and sold fruits and vegetables, made wine in his cellar, and picked herbs for his spaghetti sauce from his kitchen garden. (Courtesy Nat Martino.)

# A MODERATE PRICED LAFAYETTE HOME

Courtesy, California Homes.

### LAFAYETTE

#### R. F. JOHNSON & SON, *Builders*

A definite approach to the problem of supplying a house that can be bought by the average wage earner has been made by Horace Breed in the development of a tract in Lafayette, the other side of the Berkeley hills. Pictured here is the first of a number of homes that will be built in this area.

The plan is not only compact, but costs have been kept down through the use of dry board in construction, knotty pine in interiors, and other modern building methods which aim to cut out non-essentials, and still have a very livable home. For example, the dining room is today a smaller room, or "dinette," and a part of the living room, which saves floor area formerly taken up by a large dining room; and also allows practically one large living room for entertaining.

If purchased through an FHA insured loan, for a twenty year period, monthly payments on the house only (cost, $3800), would approximate:

| | |
|---|---:|
| Principal and 5 per cent interest | $25.08 |
| Mortgage insurance premium | 1.58 |
| Service charge | 1.56 |
| Fire insurance premium | .63 |
| Taxes (estimated) | 5.89 |
| Total | $34.74 |

With the opening of the Caldecott Tunnel in December 1937, the East Bay, including Lafayette, became more accessible to Oakland and San Francisco, allowing people who worked there to move their families to the suburbs. More homes were built to accommodate the new suburban families. This advertisement shows a floor plan for a new Lafayette home advertised in the *Contra Costa Home Builder* in 1938. Affordable, compact, ranch-style homes were built by Horace Breed using dry board in construction, knotty pine in the interior, and a smaller "dinette," rather than a large dining room to save floor area. The base cost of the home was $3,800 when purchased through an FHA loan. (Courtesy Katherine Schutt.)

The family of E. K. Wood, a lumber baron, built the Woodland Lodge on Juniper Drive in the 1920s as a summer home. There were stables, a pool, tennis court, barbecue, and a seven-hole golf course. The living room had a spectacular view of Mount Diablo. Nobel Prize and Pulitzer Prize winner Eugene O'Neill and his wife, Carlotta, lived there in 1937. In the book *O'Neill, Son and Artist*, by Louis Sheaffer, the author wrote that they "rented an estate near Lafayette. With money received from the Nobel Prize they purchased 160 acres of Las Trampas Ridge and built Tao House." O'Neill was working on a cycle of plays at that time. *A Touch of the Poet* is the only one that was finished. (Courtesy Florence Russell, *Lafayette Sun*.)

# *Eight*

# LEISURE

In the early days, besides being a farming community, Lafayette was a vacation area for people west of the town. Coming over the Summit Road or through the tunnel, some people spent leisure time in second homes, and others camped.

Although there were always animals to take care of, farmers had slow times of year once the crops were planted. After the harvest, there was time for recreation. People fished in the streams and hunted. The Henry Toler Brown diaries talk of a summertime camping trip away from Lafayette at Mitchell Canyon on the other side of Mount Diablo. Tents were rented, and 14 family members took off for six days of fishing and hunting.

There were other forms of leisure. Lafayette had a baseball team. Lafayette and Orinda had an annual tug-of-war event. There were church, May Day, and Fourth of July events.

Dances were held at the Lafayette Hotel, barns, and later in Town Hall. Town Hall dances featured a dance and meal for $1. The springy dance floor was famous for good dancing. The Sacramento Northern train scheduled a special 3:00 a.m. run back to Oakland to accommodate partygoers.

One of the special events was the Lafayette Horsemen's Association Horse Show, which started in 1935. The parade down Mount Diablo Boulevard included floats. There were many horse and roping events with awards and trophies for winners. People from Lafayette and the surrounding counties would come to show their horses and participate in horse show events.

The Lafayette baseball team is pictured here in 1900. They are, from left to right, as follows: (first row) Merle Daley, Ted McVean, unidentified, and Pete Thomson; (second row) John Weldon; (third row) Albert Lamp, Lou Doré, Lloyd Brown, Herb Daley, and Albert ?. (Courtesy Katherine McVean.)

Alice Hunt operated her very popular ice cream stands in the 1920s at Tunnel and Moraga Roads. People would eat early on Sundays, go out for a drive, and stop at the stand on the way home. They also had stands at all of the rotating dances around the county. Later she ran Ma Hunt's Kitchen on the corner of Hough Avenue and Mount Diablo Boulevard. (Courtesy Genevieve Gallagher.)

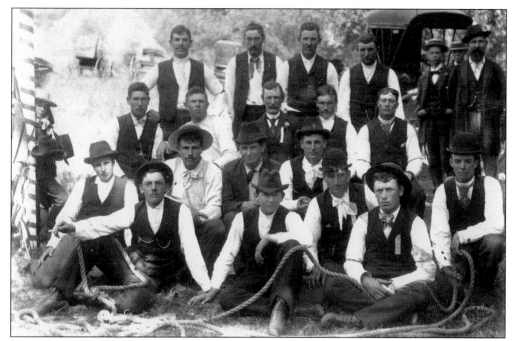

Great rivalry existed between the Lafayette tug-of-war team and the Orinda Park team. On May Day in 1894, the tug-of-war was played at the park grounds in Lafayette. Included here, in no particular order, are Roman Lassert, ? O'Neil, Peter Ehlers, Billy Curran, Charles Brockhurst, Herb Sullivan, Lew Sullivan, Rudolph Ehlers, Bob Thomson, Leonard Wilson, Gil Arregatta, Albert Lamp, and Gus Nottingham. (Courtesy Russi family.)

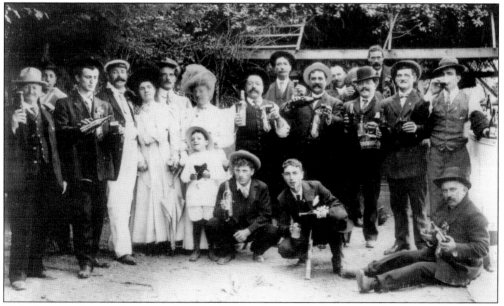

This photograph was taken around 1905 or 1906 and is possibly from a tug-of-war event. Regardless, it seems the revelers are having a good time. The man in the front row appears to have a broken baseball bat. (Courtesy Contra Costa County Historical Society.)

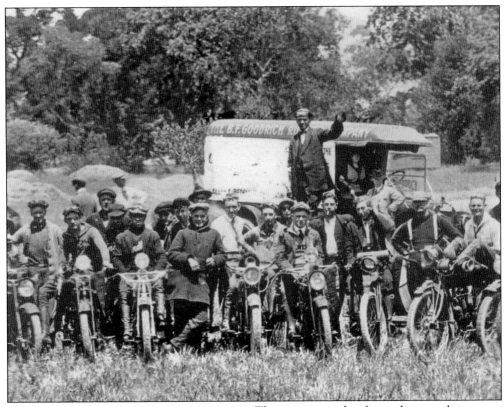

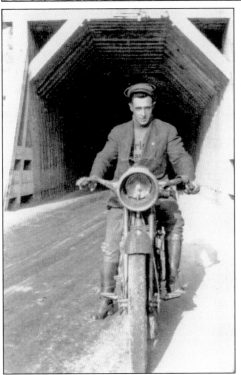

The caption on the above photograph is, "National Gypsy Tour to Lafayette, California, June 17, 1917." Members of various motorcycle clubs from Oakland and the surrounding towns would meet for the event known as the Gypsy Tour on Father's Day. It took place on Moraga Boulevard near Tunnel Road across from the creek. In 1917, the event included a barbecue in Lafayette. This photograph, actually 45 inches wide, reveals 280 people, 107 motorcycles with 19 sidecars, and 11 black automobiles. At left is Ernest Guido, secretary of the Oakland Motorcycle Club, coming out of the Kennedy Tunnel around 1915. Two months prior to the above photograph, the United States entered World War I and the draft was getting under way. Ernest Guido later died in the war. (Above courtesy Louis L. Stein Jr.; left courtesy Contra Costa County Historical Society)

Ada Ruth Shreve, pictured in her bloomers, was the daughter of Milton Shreve and granddaughter of Benjamin Shreve. This picture was taken at the gate of their ranch on the hill behind the present Plaza Shopping Center. The hammock in back indicates that some folks had time in the summer for some restful moments. (Courtesy Horace Shreve.)

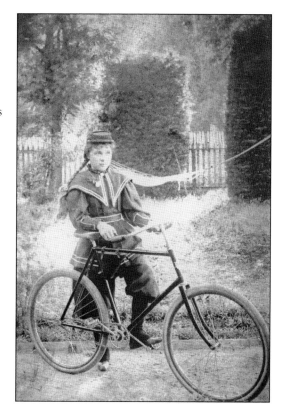

The three Flood boys are going squirrel hunting on the Happy Valley Ranch in 1915. From top to bottom are Marion Alexander, Earl Edward, and Raymond Bayard Flood. According to William McNeil, the California ground squirrels were called Beechey's ground squirrels, and they tasted a little like rabbit when cooked. For years, farmers hunted squirrels because they were a general nuisance. (Courtesy Nancy Flood.)

Coyotes, common in the area, had been known to walk up Tunnel Road, and they would try and get farmers' chickens, causing the dogs to howl. People trapped and shot the coyotes. Mountain lions were also sighted. Boys would be taught to shoot at an early age. Here Kenneth Brown, son of Lloyd Brown, is seen with his father's gun and his dog Derby. (Courtesy Sybil Brown Wilkinson.)

It is winter, and the men have been off hunting birds with the dog. Pictured are, from left to right, Stewart Miner, Ed Keefe, Fred Thomson, and J. Keel. According to William McNeil, quail and brush rabbit were plentiful in fall. In late winter, band-tailed pigeons came in large flocks to feed on acorns and Toyon berries. (Courtesy McNeil family.)

This swimming hole was provided by Pat Medau in 1925 in the creek near the old Park Theatre on Golden Gate Way. He constructed a dam 9 feet high, making a pool about 12 feet deep. Boards nailed between two trees created a diving platform. It was a popular swimming spot for kids and adults. Pat's son Al is shown sunbathing by the swimming hole. (Courtesy Medau family.)

Ken Brown remembers, "There was a time at the turn of the century when you could catch trout in Lafayette Creek. The fish and the fishermen are long gone, but the quiet old streams still flow just yards away from the city's main thoroughfare, seldom noticed by today's crowds." Here Ken Brown's father, Lloyd, fishes in Lafayette c. 1910. (Courtesy Kenneth Brown.)

In the early days, people from the cities would come to Lafayette to vacation in the summer. Some even built summer homes. The James Hubert Eckelston family from Oakland came out for extended camping. Their camp, Camp de Rosa, was in Happy Valley in 1908. (Courtesy Eckelston family.)

This is the "chow line" at Camp de Rosa to the screened dining area. There is one child at the end of the line. In this time period, children often would eat earlier, allowing the adults to have a refined meal by themselves. Meals were cooked in huge kettles on wood-burning portable stoves. (Courtesy Eckelston family.)

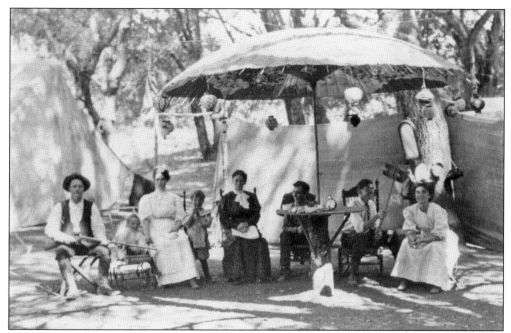

An elegant Oriental umbrella shelters the campers, and hanging from it are lanterns for evening use. Hunting would have been part of the leisure-time activities, and the man on the left holds a rifle. There were many hours for visiting in the shade of the trees and umbrellas. (Courtesy Eckelston family.)

While the campers relaxed, others went about their daily chores. The duration of the summer camping trip was long enough to require help to launder clothes. (Courtesy Eckelston family.)

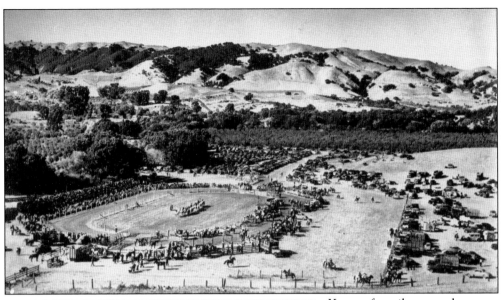

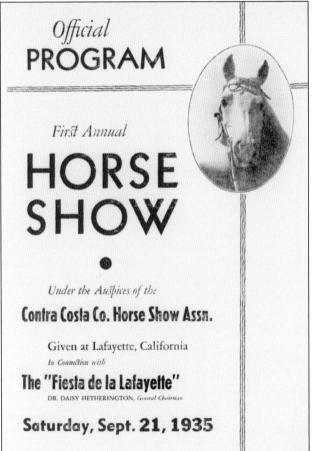

Known for miles around, a big event in Lafayette was the Lafayette Horse Show, which began as the Fiesta de la Lafayette in 1935 and ran under various names through the mid-1940s. The horse show grounds were on the Hamlin ranch on St. Mary's Road (foreground) and Moraga Road. The Fiesta de la Lafayette program is from the first annual horse show, held on a single day. In the following years, they were on a Saturday and Sunday. In 1935, there were 160 horses entered in events. Although there was a potato race and a relay race, most events involved judging the fine horses assembled. William Hull, his wife, and their son placed first in the family event. P. L. Castro and his family of 10 placed second. (Above courtesy Hamlin family; left Contra Costa County Historical Society.)

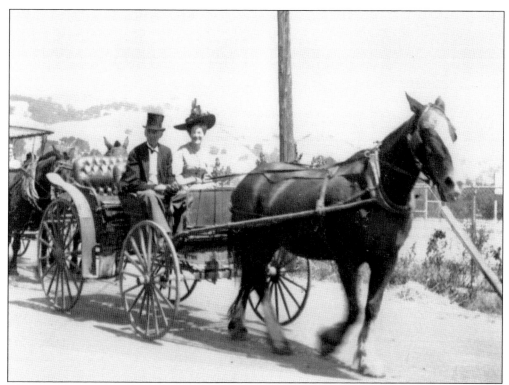

The parade was one of the popular features of the horse show festivities. In 1935, it began at 11:30 a.m. and had 216 horses, chuck wagons, and a few floats. Staged a mile down Moraga Road, it paraded onto Mount Diablo Boulevard and then to the arena. Pat Medau and wife, Lizzie, were enthusiastic costumed participants in the parade. (Courtesy Genevieve Gallagher.)

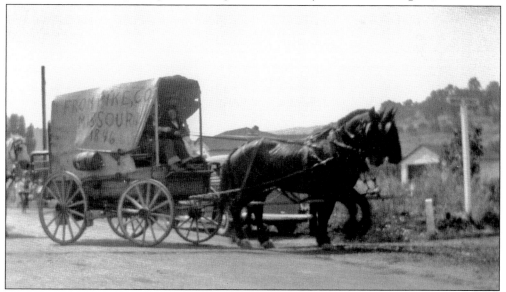

A covered wagon rolls down Moraga Road in the Horsemen's Parade in 1935. Written on the canvas is "From Pike Co. Missouri, 1846" in honor of the trek across the plains in covered wagons led by town founders Elam and Margaret Allen Brown. (Courtesy Shirley Medau.)

The horse show was more than just people showing off their horses. It was the pride of a generation of ranchers who, despite the coming of the automobile, still felt the connection to their horses and the land. In 1937, the riders make their "Grand Entry," presenting the colors. (Courtesy Hamlin family.)

Freda and Clarence Brown show their horses. The horse show was just that, and not a rodeo. However, there was a roping contest. Over the years, there was also team roping, single-steer roping, and pig roping. (Courtesy Contra Costa County Historical Society.)

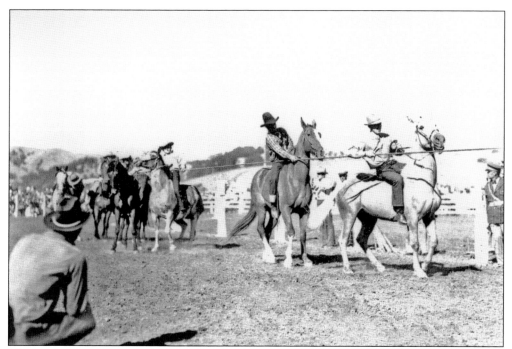

These riders participate in the tug-of-war event in 1937. Not only did they have to hold onto the rope and urge their horses to back up, but they did it bareback. Riders did not even wear gloves. (Courtesy Contra Costa County Historical Society.)

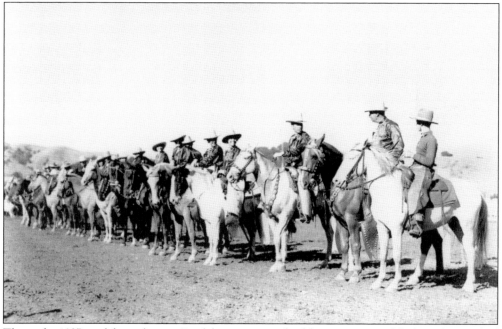

This is the 1937 stock horse lineup. Stock horses were judged for reining in and for how they worked frisky yearlings in the arena. There were events for judging Arabians, palominos, pintos, trail horses, stallions, hackamores, colts, and gaited horses. There were children's and women's events, saddle races, and watermelon races. (Courtesy Contra Costa County Historical Society.)

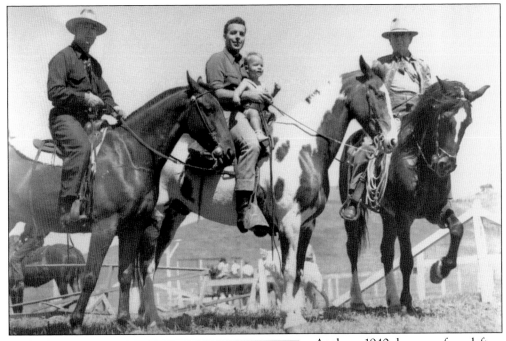

At the c. 1940 show are, from left to right, Judge O. D. Hamlin Jr., Albert Rowe Jr. (married to the judge's daughter Mignon), his son Peter Hamlin Rowe, and Dr. O. D. Hamlin. The Hamlins' land was used for the show. Their ranch was purchased in 1871, and five generations of the Hamlin family have lived continually on the land. (Courtesy Oliver Hamlin III.)

Freda Brown is seen here with some of the ribbons and trophies she won over the years at the many horse shows she participated in. Freda had beautiful horses, including Starlight and Silver. (Courtesy Clarence Brown.)

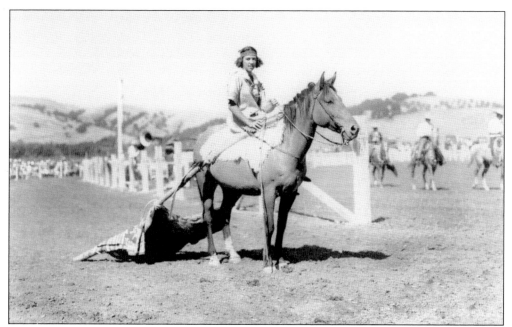

In 1937, Mary Jo King rides her horse, pulling a Native American–style travois. She appeared in seven events at the horse show, including the juvenile and musical chairs event for youths 15 years and younger on her horses named Pat, Mancha, and Buck. (Courtesy Contra Costa County Historical Society.)

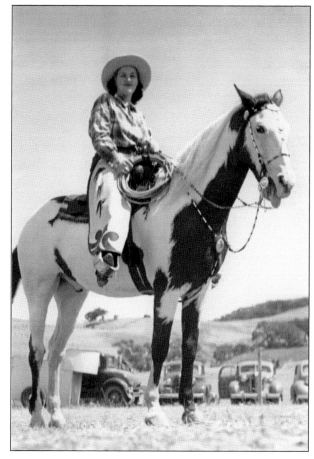

Patti Brooks Boyer and Pagero, a paint horse and former polo pony, were winners of the trophy in the Trail Class in 1939. Two years earlier, the P. L. Castro family pulled Boyer and Pagero in a trailer from El Sobrante to the parade on the Great Highway for the opening of the Golden Gate Bridge. Boyer's father, George Brooks, was the announcer at the horse show for many years. (Courtesy Patti Brooks Boyer.)

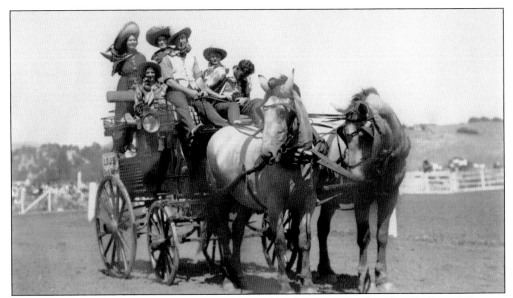

This coach, originally owned by Walter Clifton of Burlingame, was found in Redwood Canyon in poor condition. The nuts on the brass axles had the name of Clifton stamped on them. After purchase and repair, Lou Borghesani and his family drove it in parades during the 1930s. Pictured here is the Borghesani family, including F. D. Smith, Ida Smith, and driver Otto Wiseman. (Courtesy Borghesani family.)

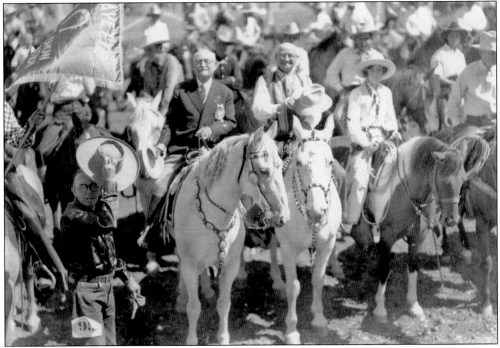

Sheriff Richard Raines Veale, center (in the dark suit), is pictured at the 1937 show. He was elected county sheriff in 1894 and served until 1934, a national record for an acting sheriff at the time. Note the Lafayette Horse Show banner on the left. (Courtesy Contra Costa County Historical Society.)